HIDDEN
HISTORY
of
LEWISTON,
IDAHO

HIDDEN
HISTORY
of
LEWISTON,
IDAHO

Steven D. Branting

THE
History
PRESS

Published by The History Press
Charleston, SC 29403
www.historypress.net

Back cover, inset: Steve Hanks, *Lewiston Tribune*.

Unless otherwise indicated, all images in this book are housed in the archives of the Nez Perce
County Historical Society, 0306 Third Street, Lewiston, Idaho, 83501.

First published 2014
Second printing 2014
Third printing 2015

Manufactured in the United States

ISBN 978.1.62619.354.3

Library of Congress Cataloging-in-Publication Data

Branting, Steven D.
Hidden history of Lewiston, Idaho / Steven D. Branting.
pages cm
Summary: "Explore the often overlooked but fascinating aspects of Lewiston, Idaho's
history"-- Provided by publisher.
ISBN 978-1-62619-354-3 (paperback)
1. Lewiston (Idaho)--History--Anecdotes. 2. Lewiston (Idaho)--Biography--Anecdotes. 3.
Lewiston (Idaho)--Social conditions--Anecdotes. I. Title.
F754.L6B725 2014
979.6'85--dc23
2013050156

For my wife, Shann, whose love for history and me mirrors my own for it and her.

CONTENTS

PREFACE

Without the expertise of Mary E. White-Romero (museum curator, Nez Perce County Historical Society), the collection of vintage images for this volume would not have been possible.

To provide the reader with some perspective, expenditures and costs for various projects have been listed in terms of their original outlays and what reasonably equivalent values would be today.

INTRODUCTION

Impermanent Memory

I have lived in Lewiston since 1952, having moved here at the age of five with my parents and two sisters. I was educated in its public schools and earned my undergraduate degree at its historic college. One would think that I should have in my memory bank a wealth of childhood recollections crowded with old buildings, celebrations, faces and voices, as well as the inevitable evidence of change over time. Sadly, that is not true of me any more than of those with whom I grew to adulthood as a baby boomer. My father died in February 1980. He was born with a cleft palate and, as a result, had a voice that has been described to me as having a slight but discernible whistle. I was so accustomed to its sound that it held no distinctiveness.

Memories are wisps that suffer from the interference, the noise, created by just living each day. How many times have you looked at an old family album, only to say to yourself, "I wish someone had made some notes about who is in this photograph." Many of my friends and colleagues would not know their own grandparents if they stood behind them in the checkout line at the local supermarket. My wife certainly wouldn't. Her mother's father died in 1911 and left no portrait that would allow her in some way to know him by peering into his eyes. This is the foremost cause of "hidden history"—a loss of connection.

This book is a collection of vignettes and flashbacks that typify Lewiston in the years since its founding in May 1861. Some stories may inspire you, surprise you or amuse you. Others may make you question our predecessors' common sense. For the most part, these events, places

and people would once have been part of the shared knowledge among the city's residents.

Unfortunately, shared knowledge does not seamlessly transfer from one generation to another. As a case in point, decades ago, whenever I had a student who was a motormouth, I used to quote a then familiar Groucho Marx line: "You must've been vaccinated with a phonograph needle." So much for using that joke in today's world of smart phones. Andy Warhol quipped in 1968: "In the future, everyone will be world-famous for 15 minutes." We find ourselves intellectually buried in a wallow of novelty that is driven by an exponentially expanding knowledge base. The static past is hard-pressed to compete.

And yet there is a subtle but undeniable blessing to all this mental fragmentation that occurs as we change along with the world around us. German philosopher Friedrich Nietzsche stated it better than I: "The advantage of a bad memory is that one enjoys several times the same good things for the first time." If these stories prove to be for you "good things," a debt will have been paid to our Lewiston ancestors, who made the same request as the dying polar explorers in poet Archibald Macleish's "Epistle to Be Left in the Earth":

Make in your mouths the words that were our names.

WOMEN AND CHILDREN FIRST

I know I have the body but of a weak and feeble woman; but I have the heart and stomach of a king, and of a king of England too.
—Elizabeth I, in a speech at Tilbury, England, 1588

The concept that history is the story of great men who changed the world is a delusion. NFL players do not yell, "Hi, Dad!" in the excitement of a touchdown or interception. Examine the life of any great man, and you will discover that his actions were profoundly influenced by family and friends, both male and female. One should never dismiss the effects that women and children have had on the development of communities. Who is not indebted to a female forebear? The following stories are but a few examples from Lewiston's past.

THE SAFETY OF A SISTER'S LOVE

One of Lewiston's most heart-touching stories played out in part on February 10, 1958, when three sisters started school at Webster Elementary. Six orphaned girls were beginning a new life, with their older sister as their new mother. On January 30, Mr. and Mrs. Clarence Larsen of Pine Creek, Idaho, were killed in a highway accident, leaving behind their daughters—Linda (twelve), Julie (ten), Toni (nine), Kristie (six),

Nola (three) and Viola (two). Oldest sister, Leona Moore, twenty-eight, filed for and was granted the right to be the children's legal guardian. She brought the girls to Lewiston, where she and her husband lived.

The community immediately rallied to their side, providing a small home rent-free until a larger house could be found. Lumber was donated to add a bedroom to the home. Lewiston residents donated cash and a number of appliances. By February 13, $136 ($1,100 today) had been raised. A mothers' club said it would provide new clothing as the girls grew up. Their fifteen-year-old brother joined them later.

A LANDMARK OF A FADED PAST

After Morris Hall, the original women's dormitory at Lewiston State Normal School, was destroyed by fire, the school rushed to provide adequate living accommodations and convince the parents of prospective female students that the college would take care of their daughters' comforts and safety. Lewis Hall opened in 1907. The building had fireplaces throughout and a spacious commons area. At one time a hall for married couples who were students, it was torn down in the early 1970s and replaced with a new science building of the same name.

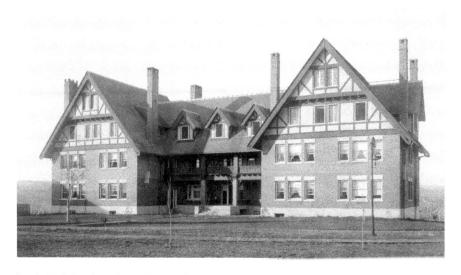

Lewis Hall, Lewiston State Normal School, circa 1911.

ALL CREATURES, GREAT AND SMALL

A 1944 Lewiston High School graduate, Mardell West became a duly licensed Idaho veterinarian in June 1949 after completing her five-year course of study at Washington State College (now Washington State University). When interviewed, she commented that she found nothing unusual about the fact that she was Idaho's first female veterinarian. She had been interested in animals since she was a child. Her ability with and love for horses won her the title of queen of the Lewiston Roundup in 1947.

After spending a brief time handling the clinic of Dr. Kenneth White, she joined the Metcalf Animal Hospital in Missoula, Montana, and married John Schara in April 1950. She returned to Lewiston in 2009 at the age of eighty-three to attend a reunion of Roundup royalty. She said, "Lewiston has changed so much since I lived here. I don't recognize anything."

ALL DRESSED UP FOR THE PLAY IN 1893

By the early 1880s, Lewiston's newspapers carried society columns, replete with stories of gala events and fashionable parties, one of which the young women pictured attended in costume. Literary and cultural societies

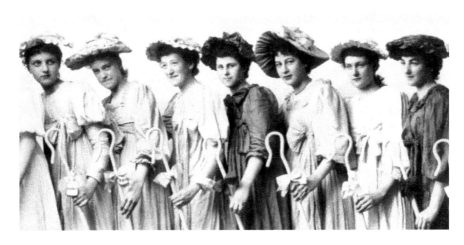

Left to right: Lillian Orcutt, Flora Coburn, Ada Thatcher, Gussie Benson, Jennie Peabody, Gertrude Kettenbach and Adelia Lindsay.

attracted residents desiring culture on the frontier, and local thespians were busy regaling the public with entertainment to rival the traveling troupes to appear at the Grostein & Binnard Grand Opera House.

A BOY SCOUT IS ALWAYS PREPARED

Lewiston's Bobby Ray Myers, a member of Boy Scout Troop 121, saved the life of John Delane, age four, after John's clothing caught fire from a rubbish blaze in a downtown alley on October 31, 1939. Thirteen-year-old Bobby was working in the back of a grocery store and heard the child's cries. Finding John running down the alley with his clothes afire, Myers extinguished the blaze and instructed Delane's mother in giving first aid by applying a baking soda dressing.

He was credited with saving John's life. John received second-degree burns to about two-thirds of his body and was confined to the hospital for six weeks. Myer's scoutmaster, Marshall Hyde, said, "This is the payoff for my six years of work with the scouting movement—a splendid demonstration of scout first aid and initiative."

Scouting's founder, Robert Baden-Powell, expressed it best: "A Scout is never taken by surprise; he knows exactly what to do when anything unexpected happens."

THE ANCHOR OF A MOTHER'S EXAMPLE

Mrs. Ruth Stark Millay was Idaho's first "Mother of the Year" in 1947, and for good reason. She was widowed in July 1921, leaving her with five children aged eighteen months to thirteen years. Her husband, Francis Ernest Millay, was the dean of rural education for Lewiston State Normal School. In 1909, the Normal was the first college or university in the Pacific Northwest to implement a curriculum to train teachers to work in rural schools.

Ruth and Francis had met as classmates at Cheney State Normal and graduated together in 1905. They married on November 7, 1907. After Francis's death, she scraped together her meager resources and purchased a tract of land in the Orchards, where she built a home. She and her children raised chickens, vegetables and berries to help with expenses. When her

youngest child turned seven, she felt she could leave them and go back to school. She trained at Lewiston State Normal and received her BA degree in 1946, at the age of sixty-one, from Washington State College.

Millay was a Lewiston teacher for many years, working at Orchards Elementary for twenty-five years in the second grade. After retirement, she championed the creation of a library for the Orchards. "My children had to walk to town to get books," she said. Those were the days when Lewiston's library was located in the old Carnegie in Pioneer Park. The Orchards library moved from place to place until it closed in December 1956. The

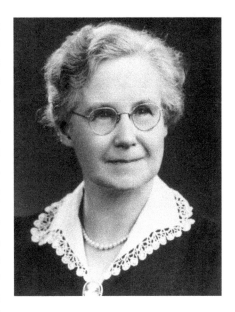

Ruth Millay, 1947. *Courtesy of Bill and Carol Stillman.*

collection was stored until the Nez Perce County Library opened in 1959. She died in October 1970 at the age of eighty-five.

WHEN A BEST-LAID PLAN FAILED

The Salk vaccine saved thousands of lives but brought terrible heartache to others. On May 1, 1955, seven-year-old Bonnie Pound was placed in an iron lung at St. Joseph's Hospital after her condition worsened. She had developed Bulbar-type polio, which affected her ability to breathe, speak and swallow. Bonnie had received her vaccine at Whitman Elementary School. Lewiston had one iron lung ready. Another girl from a nearby town died soon after from complications. Bonnie spent four months at St. Joseph Hospital, followed by treatment at the Elks Rehabilitation Hospital in Boise.

On December 15, 1962, superior court judge Marvin Sherwin, Alameda County, California, awarded Bonnie, then thirteen, $70,000 ($525,000 today) in settlement of her claim that she had contracted polio from the Salk vaccine, produced by Cutter Laboratories, which paid out claims in fifty suits. Bonnie's was the largest settlement for an affected child in the Pacific Northwest.

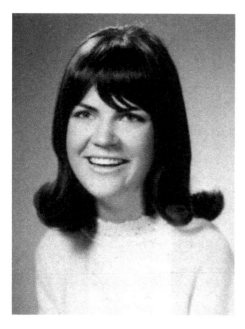

Although requiring a back brace and arm braces for several years, Pound would continue her education and graduate from Lewiston High School in 1966. In a 1978 interview, Bonnie said that "I sat there and cried" when her two-year-old daughter received the latest polio vaccine.

Bonnie Pound, 1966. *Courtesy of the Branting Archives.*

THE LAST SACRIFICE OF A BROTHER'S KEEPER

When the returning students arrived for the first day of history classes at Lewiston State Normal School in the fall of 1903, they were startled by changes in the demeanor and physical well-being of their teacher Henry Talkington. Although only forty-two, he now seemed much older and noticeably frail. His hand continually shook as if he had contracted Parkinson's disease. Talkington must have reminded the students of the aging Civil War veterans who marched in hometown Fourth of July parades, many of whom lived with more than the physical scars of brutal combat. What had happened to Talkington? It was an answer some students already knew but were too polite to discuss with their professor.

Born near Fort Smith, Arkansas, on November 2, 1860, he was the son of a farmer whose wife was the daughter of a Presbyterian minister. His father, Stephen Jasper Talkington, was conscripted with two brothers into service for the Confederacy with the Thirty-fifth Arkansas Infantry and died on January 13, 1863, three weeks before the birth of his second son, John. His mother, Sarah, took her two small children to Springfield, Missouri, where Henry would receive his public schooling. His mother married widower Berry Looney on November 28, 1869, and would bear him seven children from 1870 to 1881.

From 1873 to 1914, Springfield's Drury College (now Drury University) operated a preparatory academy. Talkington was first a student in the Drury Academy from 1881 to 1883 and then entered Drury College proper, graduating cum laude in 1888 with a degree in the Classics. He began his teaching career at an Indian boys' seminary on the Cherokee Nation reservation in Oklahoma. In 1890, he moved west to take up a position at the Pendleton Academy in Oregon. The Methodist-Episcopal Church, which established Wilbur College in Lewiston in 1882, had opened a small school in Weston, Oregon, calling it Weston Academy. The state took over operations in 1885, and in 1893, Talkington was appointed the vice-president of what had become Weston Normal School. In 1894, he earned a master's degree from Drury.

On June 29, 1892, Talkington married twenty-year-old Carrie L. Gwynne, who had emigrated from England in 1886 and attended Iowa State Normal School (now the University of Northern Iowa), graduating in 1891. It would seem that Henry and Carrie met at the Pendleton Academy. The birth of three children followed in quick succession: Ruth (1893), Arthur (1894) and Paul (1896). After four terms at Weston, Henry took the family back to Pendleton, where he had been hired as a school principal. The Talkingtons arrived in Lewiston on August 1, 1899, after his appointment to head the Department of History at Lewiston State Normal School. He quickly became a popular teacher and was the supervisor of Idaho's first men's college dormitory, Reid Hall, which opened his first semester.

When Lewiston State Normal School was authorized in 1893, the state legislature failed to provide adequate funding, and the financial panic of the same year forestalled development of the college. Lewiston donated ten acres of land for the campus. George Knepper, the school's first president, arrived for work on November 1, 1895, and found that construction delays left him without a building in which to teach. He approached Robert Grostein and Abraham Binnard to

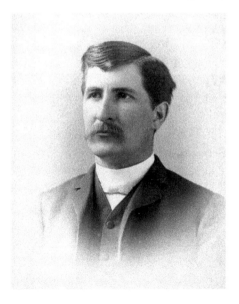

Henry L. Talkington, circa 1907.

19

rent their local theater for classes to begin on January 6, 1896. The new building was finally completed and dedicated with great fanfare on June 3, 1896. Knepper struggled with money issues to keep the school going. Although the enrollment and income from student fees had increased, the school remained desperately short of funds. So Knepper turned to the community. Residents responded with a needed piano and contributions to buy books to start a library. Two badly needed dormitories—Reid Hall and Morris Hall—were erected. With no indoor plumbing and cesspools, it is a wonder that students were not constantly ill.

The school got its dormitories, but the stability of the school's administration was in jeopardy. By 1901, George Knepper had alienated members of the board of trustees as he tirelessly lobbied for funds and buildings. The faculty knew that their jobs were in danger as a result of the unsettled internal politics. The stink on campus emanated from more than just outhouses.

Henry's mother died in March 1902, and the next school term started off on a tense note and remained tense. Knepper's powerful ally and board of trustees president James W. Reid died in January 1902. The patience of the board of trustees ran out, and his contract as school president was terminated in 1903. How would the incoming president, George H. Black, handle the school's problems? Henry and Carrie may well have begun to make plans to move back to Oregon. As has been the experience of many current teachers, Talkington finished the spring semester not knowing if he still had a job.

Jobs and labor had been an important issue in Lewiston that spring. On March 2, 1903, the eight-hour workday went into effect for Lewiston's local building trades unions (mason and bricklayers), with wages set at 45 cents per hour ($11.30 today). The local laborers' union settled for $2.50 per day ($63.00). Two months earlier, the carpenters' union had posted resolutions declaring that on March 2, eight hours would constitute a day's work. All of the contractors in town agreed. Most Americans worked twelve- to fourteen-hour days. Based on the best evidence, these events were the genesis of the eight-hour day in Idaho.

For Paul and Arthur Talkington, it was just another summer playing with classmates and exploring the open fields that stretched from campus beyond the ungroomed Normal Hill Cemetery and across the slough that extended from the Snake River up what is now Southway Avenue. The boys and their sister, Ruth, were used to walking throughout Normal Hill. They attended old Whitman School, which was located downtown, where the North Idaho

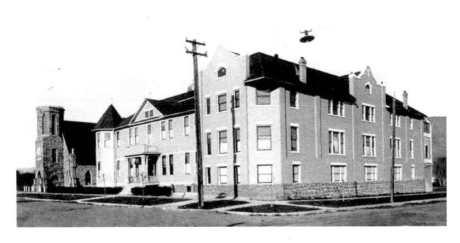

Visitation Academy, circa 1910. The academy was the portion of this building to the left of the power pole. *Courtesy of All Saints Catholic School.*

Health District offices are now found in the old Safeway building. They would walk past the newly opened St. Joseph Hospital and Visitation Academy, a girls' boarding and finishing school that later became St. Stanislaus School. A building boom for homes on Normal Hill was well underway, led by the Vollmers, Binnards and Bunnells.

The Snake and Clearwater Rivers were popular swimming spots from the city's very earliest days. However, anyone who lived in Lewiston before slack water arrived in the mid-1970s knows how much more treacherous the rivers could be. A simple Google search will bring up newspaper reports of deaths from drowning in Lewiston as far back as 1888. Although supervised beaches were available, the legacy of deaths finally led the city to construct a municipal pool in Fenton Park after World War II. The rivers were also a favorite for suicides. In January 1899, a few months before the Talkingtons arrived in Lewiston, Emma Tobin and Medora Clindining threw themselves into the Clearwater to end their lives within a few days of each other. Medora was only sixteen years old.

June 1903 was a dry month, unlike the unsettled weather we have come to expect for the late spring in Lewiston. In short, it was perfect for baseball games, fishing trips, swimming and treasure hunts. Paul and Arthur had a particular and favorite spot to visit. Local shooting enthusiasts were well organized. Several locations served as shooting grounds, including a range on the banks of the Snake River near Cox's Slough, where Southway and Snake River Avenues now meet. Founded in 1881, the Lewiston Gun Club was Idaho's first and the oldest continuously operated club in the United

States. Local children liked to visit the grounds to look for empty cartridges and the pieces of the "blue rocks" used by the shooters. Made from a combination of lime and pitch, the Blue Rock Target first appeared in 1880. Today, we still call it a clay target or clay pigeon.

On Tuesday, June 30, 1903, at about 4:00 p.m., the boys asked their mother for permission to head down to the shooting grounds to look for keepsakes. When sunset came and the boys did not arrive back at home, Henry walked to the area and found the footprints of the boys in the wet sand. The larger track was a match for Arthur's shoe, the smaller for Paul's bare foot. Carrie remembered that Paul was not wearing shoes when the boys left the house. The prints led into the water. Henry alerted neighbors, who joined him in a search along the shore until 10:00 p.m., when a general alarm went out.

At first, the Talkingtons entertained the hope that the boys had taken the downstream Pearcy Ferry to Clarkston, where Henry had a small placer claim and had been working that day. While police officer William Hadley crossed to Clarkston to make inquiries, a search party of about forty men spread out along the Snake River banks.

Henry and Carrie were said to be "almost prostrated over the disappearance of their loved ones." Neighbors and friends flocked to the family home to assist in any way they could. Some felt that, after leaving the shooting grounds, the boys had lost their way in the dark among the sagebrush and sand hills that characterized the area more than a century ago. Maybe they had just lain down to sleep until morning light. No one reported seeing them on the riverbank, and the boys were not accustomed to playing near the water or swimming except when accompanied by their father. Where were their clothes if they had gone swimming? Some even thought that the boys had slipped aboard the riverboat *Imnaha*, which had made its maiden trips up and down the Snake earlier during the day.

At 1:00 a.m., the search was suspended until sunrise. A local fisherman came forward with news that at about 6:00 p.m., he had seen the boys descend the grade from Normal Hill to the river where Eleventh Avenue now drops to Snake River Avenue. His impression was that the boys were chasing butterflies and were running around without seeming to be heading anywhere in particular.

Paul was described as a boy with a "rather peculiar and stubborn disposition." A few days before, something at the house had upset him, leading him to hide himself under the porch steps all night. Some thought that the boys staying out all night was just one of those things kids do.

At about 4:00 a.m., Willie Culver came across the boy's clothing on the shore, and word was sent to Henry, who was riding his horse through the sage, hoping to find them sleeping there. Henry retrieved the clothes and returned home to comfort Carrie and Ruth. What little hope they had was gone. Henry even alerted steamboat crews to be on the lookout for the bodies. When the clothes were found, the tracks in the sand showed that the search party the night before had been within a few feet of where the boys' bodies were submerged.

As soon as the clothing was located, Christ Geilus, a fisherman and boat owner living nearby, was summoned. A seine net was attached to the bank at one end, while the other was swept through the water by a boat. Arthur was found first, shortly before Henry returned from the family home. Then Paul's body was located. Onlookers commented that Henry could not look, turned from the scene and was led away by friends.

Officials began to reconstruct the probable events that led to the tragedy. To some, the evidence pointed to the children entering the water where a narrow channel formed between the shore and a small island. The bottom sloped gradually for some distance and then broke off suddenly into deep water. The consensus was that the boys started to wade to the island and,

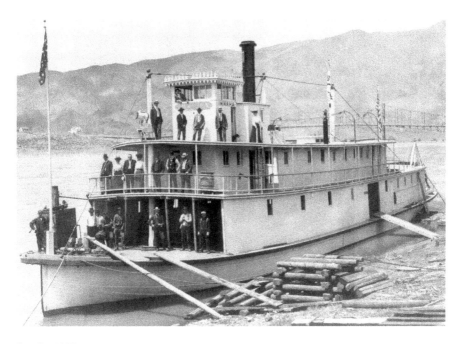

Imnaha, 1903.

upon reaching deep water, were swept away. Tracks on the shore where the water was shallow showed that they started to cross. Their dog's prints were found on the island's bank. The dog had returned home the night before without the boys. People had dismissed it as just a case of a mongrel that might leave its masters at any time. The dog knew the truth.

Others interpreted the evidence quite differently. The boys had been seen on the shore watching the *Imnaha* steam up and down the river, testing its engines. When the waves created by the stern wheel came ashore, the boys were seen to run out and let the waves catch them. It was thought that a wave came in so high that it overwhelmed Paul, nearly carrying him off his feet. However, the boys thought it was great fun and returned to testing their swimming skills. The boys followed the boat and continued their dangerous game. A hog raiser farther upriver saw their clothes on the shore as he passed but thought the boys were hiding in the brush.

One fact could not be misinterpreted. The condition of the boys' bodies indicated that Paul drowned first and had been submerged about an hour before Arthur died. It would seem that Arthur became desperate over the loss of his little brother and had given up his own life trying to recover his body. It was the last sacrifice of a brother's keeper.

The boys were taken to the Vassar Funeral Parlor. Originally, a combination furniture store and undertaking salon in the old Grand Hotel building, the firm had only recently opened the first exclusive mortuary in Idaho. After the bodies were prepared, they were taken to the Talkington home for the funeral, which was held on Friday. A large number of classmates and other children attended. The boys were buried together in a double white casket after being transported to Normal Hill Cemetery in a white-draped hearse, white being the traditional color for a child's funeral.

> *A wife who loses a husband is called a widow. A husband who loses a wife is called a widower. A child who loses his parents is called an orphan. But… there is no word for a parent who loses a child, that's how awful the loss is!*
> —*Jay Neugeboren*, An Orphan's Tale, *1976*

The moment a child perishes, a great chasm opens between the grieving parents and the world and indelibly clouds the remainder of their lives, even if they have other offspring. No child can or should carry a parent's grief. Time and technology have not changed these basic and universal truths. And no parent today will mourn any more than the fathers and mothers of ancient Egypt, Europe of the Middle Ages or frontier Idaho.

Henry L. Talkington (back seat, center) with George Black, the new president of Lewiston State Normal School (front seat, wearing glasses), circa September 1903. Reid Hall, Idaho's first men's dormitory, stands on the left.

When George Black arrived at the Normal School, he fired the entire faculty, except Talkington, who was no doubt surprised, as he had been a close and trusted associate of Knepper. The relief of employment may well have been enjoyable, but the summer of 1903 had been an *annus horribilis* compressed into a few days.

The events of that terrible day did not end with the funeral. Talkington was a changed man, and the *Imnaha* became an ill-fated boat. Anyone who has traveled on the Snake River through the Mountain Sheep Rapids knows the very real danger that boats can experience. The rapids are very steep. At the turn of the twentieth century, steamboat operators used an ingenious method to lift their crafts over the rapids. A "deadman," or heavy post, was anchored onshore. The steamboat would grapple a cable attached to the deadman and wench itself through the rapids. Once clear, the cable would be cast free, attached as it was to a keg that would allow it to float downstream for the next boat's use.

On November 8, 1903, the method did not work cleanly for the *Imnaha*, built in Lewiston to haul freight and passengers upriver to the mines at Eureka Bar. The cable became fouled in the eccentric rods that powered the stern wheel. The rocker arms broke, and the engines could no longer

drive the boat. Captain Harry C. Baughman tried to maneuver the boat as it drifted back toward Mountain Sheep Rapids. The rudders would not answer, and the boat crashed into the rocks. As the stern came around, the forty passengers and crew leaped ashore. One horse was lost. Wreckage was scattered for twenty-five miles downriver. Four deckhands returned in an attempt to salvage materials. Overloaded on the trip back to Lewiston, their boat capsized, and one man was drowned.

Seneca wrote, "Great men rejoice in adversity just as brave soldiers triumph in war." In the aftermath of the boys' deaths, Talkington threw himself into his work as a teacher and author. Several important books followed, along with his appointment as one of the first three trustees of the Idaho State Historical Society in 1907. A second daughter, Catherine, was born in 1909. He spearheaded the development of the normal school's library, whose ten thousand volumes were consumed by the fire on December 5, 1917, that destroyed a major portion of the old administration building. In 1913, Talkington wrote several popular articles for the golden anniversary of the Idaho Territory. A museum grew up around his personal collection of artifacts used to illustrate his lectures. In the spring of 1939, he was told that he could not return to the classroom for the fall classes under the terms of a mandatory age regulation passed by the state board of education in 1938 requiring college faculty to retire at the age of seventy. His last publication, a condensed history of Lewiston, appeared in 1945.

On November 6, 1930, Talkington Hall, Lewiston State Normal School's fourth women's dormitory, was dedicated, allowing Spalding Hall to convert to a men's dorm, something the Normal had not had since Reid Hall was sold more than twenty years before. Ironically, the state board of education and the superintendent of public instruction were prominently in attendance to honor Talkington.

In 1943, the Talkingtons sold the home they had owned since the 1920s next to the Congregational-Presbyterian Church and moved into a tiny house at 24 Third Street. And, no, the quiver in his hand never left him. He died in November 1949. Carrie died in February 1954.

Daughter Ruth married Harold S. Quackenbush in June 1921 and moved to Portland. Stricken with multiple sclerosis, Catherine never wed and worked for several years at the Carnegie Library. In her last years, she lived at the old Somerville Home in the East Orchards, dying there in 1968. Opened in 1920, Somerville was the county's hospital and nursing home, replacing the county poor farm east of the city.

Within days of Henry's death, C.C. Lame, a former student and one of Talkington's pallbearers, recalled an article he had written about his old professor several years before, entitled "The Man Who Taught Me the Most." And so, I close with his assessment of his mentor:

> *I learned through his guidance that genius is about 99 per cent hard work. He said that many times special talent of too high a degree was the very thing that caused many individuals to fail. The courage to go on in a race you cannot win is greatness. Hindrances cause us to discover the worth in things and unsuspected values of men. Life cannot be too easy.*

TAKING THE REINS FOR HERSELF

When Lewiston mortician Clyde James Vassar died suddenly in August 1920 at the age of forty-five, his wife, Alice, was left with six children at home. So she did what she had to do: assumed ownership of the undertaking business founded by Clyde and his father, Joseph, in 1898 in a building at the site of the current YWCA. That career move made her the first woman to become a licensed mortician in Idaho. A fire in 1934 forced a major renovation of the old Robert Grostein home that has served as the funeral home since 1907. She sold the firm to her sons Andrew and Vincent in 1948. Alice lived the last years of her life in the Lewis-Clark Hotel and died in March 1960.

Alice Vassar, circa 1950. *Courtesy of Vassar-Rawls Funeral Home.*

A MOST UNUSUAL SPRING BREAK

Reconstructing history requires a penchant for reverse logic, the skill to replicate the past from the trail of factual minutiae and crumbs left by each generation, without confusing the past with the present. So it is with the set of circumstances in 1888 that seemingly forced the Lewiston school district to accelerate and formalize its plans for a proper high school. However, that is getting a little ahead of our story.

In the fall of 1863, when Lewiston contained as many tents as stick and frame structures, the community witnessed the opening of its first "subscription" school in a one-level storefront on the southwest corner of Third and C Streets. Erected the previous year, the building was for a time an assay office and housed the firm of McIteeny & Terry, retailers of books and drugs. The Territorial Council rented it for its first session. The structure had "breezes of ventilation sailing through wide cracks between the logs," complained Alonzo Leland, the first "superintendent of schools," if only in an advisory role, and later the editor of the *Lewiston Teller*. Wood-burning stoves provided the heat; windows supplied the only light. The first blackboard and chalk were not used until 1867.

The school year was anything but regular, with three-month sessions being the norm, if a "qualified" itinerant teacher happened to stop in Lewiston. According to the territorial superintendent's report for 1869, the average term was only two months. Few early teachers stayed for more than one term. Most were men "better equipped mentally than morally. It was not at all uncommon for them to be tipplers and card players." Some exceptions were Miss Emma Kelly, daughter of the first judge of the district court and teacher for two terms, and Professor Eckels, who introduced the blackboard. A teacher in the 1870s and early 1880s could expect to earn no more than $40 a month ($1,000 today).

By 1871, concerned citizens were agitating for the construction of a proper schoolhouse instead of renting a building, as had been done theretofore. Until 1867, local residents had been little more than squatters on government land. That year, the federal government conducted a survey of the territory along the Boise Meridian and created a Lewiston township, issuing patents to lots. Sometime previously, one unnamed enterprising fellow took a liking to Lewiston and to a patch of land near the east end of town, on what would become Tenth Street.

He did not keep the property for long, anteing up his patent title in a card game to cover the bets of his opponents. Chester P. Coburn, head of the

school board, saw an opportunity and approached the winners—James W. Hays, Albert Ripson and L.W. Bacon. He actively lobbied them to donate the property as a site for a new school. Bacon had been the first elected county assessor and a member of the first territorial legislature in 1863–64. Ripson held the majority share and quitclaimed his deed. His partners consented, and the district court finalized the transaction.

Whatever the truth of the card game story, the parcel was officially deeded for school use on February 10, 1876, by Mayor Henry W. Stainton, who was a school trustee. Dr. Stainton had been granted trusteeship of all Lewiston properties subsequent to the formal city survey of 1874. The new school grounds extended from Main Street to the base of what is now called Normal Hill and from Tenth Street to Eleventh Street. By the 1880s, the neighborhood included several houses of worship, notably the original Methodist, Presbyterian and Episcopalian congregations, located on "Piety Corner," now Eleventh and Main Streets. For many years, Tenth Street was officially known as "School House Lane."

Students and teachers finally completed their first nine-month school year in 1878–79. Then, in December 1880, in one of its initial acts, the Eleventh Territorial Legislature chartered Lewiston as Idaho's first public school district. With the arrival of James A. Gardiner as administrator in 1881, the school was divided into grades, but it would be a while before every student received textbooks, which had been introduced in 1879.

In 1882, Lewiston residents passed their first bond election for $11,000 ($260,000 today), which paid for the construction of a stately three-story, wood-framed building, replacing the 1872 structure, which had quickly become too small for the growing student population. In the spring of 1888, during which time the Sanborn Map & Publishing Company was surveying the town to complete an insurance plat, events converged to create Lewiston High School. The term "high school" had been used as early as 1883 by Gardiner to describe some of the older students' work, but no formal high school curriculum was in place. Any advanced work pretty much depended on the skill and will of the teacher. As with many school districts across the country well into the twentieth century, most students ended their educations at the eighth grade. For American children, eighth grade graduation was one of life's highlights. People still debate the difficulty of state proficiency examinations from those years.

In Lewiston, tension among the public school faculty had polarized the teachers and students. The elementary school teachers were at odds with the lone instructor for the older children, M.L. Johnson. Those problems spilled

over into the school board, which dismissed Johnson in March 1888 for reasons now clouded by a lack of records and confidentiality and complicated by the fact that the school board held only one reported meeting a year at the end of April. Many did not take the firing well. Several of Johnson's male students (with the permission of their parents) walked out and refused to attend the public school anymore.

Johnson set up his own school in the Grostein & Binnard Opera House, located on the west end of Main Street, some ten blocks away. The "truants" followed and enrolled at the new school, where they studied mathematics and American history, completing the school term on their own terms.

The issue soon became less personal and touched off a debate about civic pride and the public good. Had not Boise graduated its first high school class—two boys—in 1884? Once the territorial model, Lewiston was rapidly losing its status as a progressive community. Now the subject of parent complaints and increasing community attention, the school board responded and quickly moved to standardize a two-year high school curriculum, albeit without Johnson as its head. At its annual meeting, a description of which was printed in April 1888, the school board hired C.A. Woody, who was an educator in Wichita, Kansas, to be the principal for $125 ($3,200 today) per month. The annual school report, printed the *Lewiston Teller*, July 19, 1888, makes no mention of any personnel problems.

The schoolhouse dispute was overshadowed by two other issues stirring the community pot. Moscow had been openly lobbying Congress to create a new county and framing a little "mischief by law" by taking advantage of the county coffers to press its point. There was also substantial popular support for the campaign to have north Idaho annexed into Washington, a move that was averted by President Cleveland's refusal to sign the bill sent to him by Congress. (See chapter 5.)

And to make matters worse, in December 1888, the city council forbade any further burials within the city limits and began instructing local families to remove the remains of their dead loved ones from the old cemetery (located in what is now Pioneer Park) and relocate them. Most bought plots in the newly opened city graveyard south of town, now known as Normal Hill Cemetery. Clearly, Lewistonians had a lot on their minds.

The school board was left with another problem when Woody never took the job. In his place, Charles A. Foresman accepted the position and became the first official principal/teacher for Lewiston High School at the wage offered to his predecessor. Born in 1859, Foresman had been trained at the Indiana State Normal School and was new to Idaho. From the

attendance reports printed monthly in the *Lewiston Teller* in the fall of 1888, he had organized a "high school room," along with a grammar room, a primary room and an intermediate room—each with its own teacher, paid $60 ($1,500 today) per month.

Under Foresman's leadership, nine students had enrolled for high school courses. At its April 26, 1889 annual meeting, the school board adopted a "uniform series of textbooks," contracting with A.S. Barnes & Co., a leading national publisher of textbooks in the nineteenth century. Among the titles listed in the three-year contract were the popular Joel Dorman Steele series in physics, chemistry, botany and astronomy—all clearly intended for an intensive high school course of study. Lewiston had taken a little detour but was closing the "education gap."

The new curriculum quickly bore fruit. In May 1890, four girls earned their diplomas in the first official graduating class. The four-member class of 1891 included Louis Roos, who later served as adjutant for the First

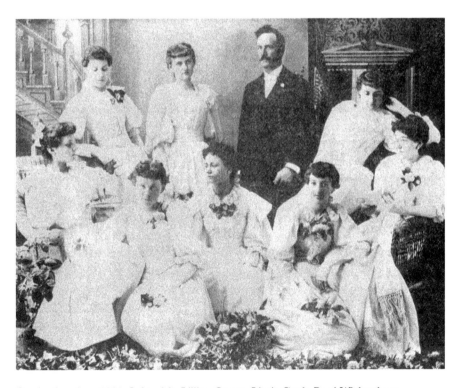

Graduating class, 1894. *Left to right*: Lillian Orcutt, Lizzie Cook, Pearl Wickersham, Maud Wildenthaler, Jennie Harrington, Charles Foresman, Louise Alexander, Gertrude Kettenbach and Mattie Barton. *Courtesy of the* Lewiston Tribune.

Idaho Volunteers during the Philippine Insurrection (1898–99) and private secretary to Idaho governor Frank W. Hunt. Principal Foresman married Kate Lowe Kennedy in August 1891. No classes graduated in 1892 and 1893. The first formal graduation ceremonies were conducted at the local Masonic Hall on First Street for the all-female class of 1894.

Foreman's career would take many turns, but Lewiston had surely gotten an organized and ambitious man. In March 1890, when Alonzo Leland retired because of age and ill health, Foresman purchased the *Lewiston Teller*. He expanded the content of the newspaper and increased its circulation, steering its editorial bias to a decidedly Republican position, causing it to be described as "one of the strongest and most influential Republican papers in the state, having been a potent factor in the growth and upbuilding of this section of Idaho."

His role as high school principal ended in 1894. The Idaho Republican Party rewarded Foresman for his loyalty by nominating him for state superintendent of public instruction, an election he won in November. Katie bore him a son, Kennedy, in late December. In 1895, he returned to present the diplomas to the graduating class, the only time a state superintendent has done so in Lewiston. He served for two years, "a credit to himself and the state," returning to the newspaper business at the *Teller* after becoming a casualty in the Populist landslide election of 1896, expanding the newspaper to a twice-weekly publication in December 1898. After divesting himself of his interest in the paper a few years later, he represented Nez Perce County in the Tenth Idaho Legislature (1909–10). He then moved with his wife, Katie, and their two children briefly to Wallace, Idaho, and later to Yakima, Washington, where he became active with the Commercial Club. His newspaper columns could be found in the *Yakima Herald* as late as 1923. He died in 1942 at age eighty-three. Katie survived him, dying in 1946.

Lewiston schools continued to expand after Foresman's departure, beginning with the leadership of W.O. Cummings, who served until 1897. In response to overcrowding, the community passed a $15,000 ($385,000 today) bond in 1898 and erected a new high school directly south of the 1882 building.

Lewiston shed its isolation that year, when Company B of the First Idaho Volunteers left for service in the Spanish-American War. On Tuesday, May 3, 1898, all classes were cancelled so the children could join their parents to cheer as the troops left the wharf on Snake River Avenue to start their journey to the Philippines. In February 1899 came the sad news that Edward McConville, a community leader since the 1870s, had been killed in action

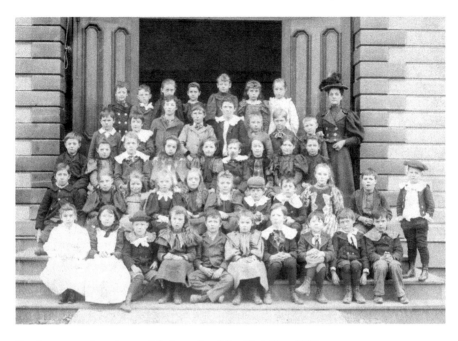

Lewiston second graders and their teacher, Mrs. Cash Day, 1896.

at the Battle of Santa Ana. His burial at Normal Hill Cemetery in April was attended by the largest assembly of mourners in Lewiston's history.

Lewiston High School added a third year to the curriculum in 1899, when the board of trustees hired R.N. Wright, formerly of Astoria, Oregon, as the first full-time superintendent. As a result, three students—Norma Vollmer, Norman Vollmer and Harold Hurlbut—had the distinction of being the only students to graduate twice from Lewiston High School, in 1899 and 1900 (the class that chose purple and gold as the school's colors).

Superintendent Wright continued his innovations. Joel Jenifer became high school principal in 1903, and the high school added its fourth year in 1904, which saw no graduates, the last time this has occurred. High school classes and faculty members were organized into departments. In 1903, Lewiston High School became the first school in the Pacific Northwest to have a commercial department. Student publications began in 1904, and the Lewiston High School band became the first in the Northwest in 1906. By 1907, Lewiston's school population had risen to 1,300, and the superintendent's salary was $2,000 ($47,000 today) a year. Enrollment at the high school reached nearly 200 by 1909. In just two decades, Lewiston High School had outgrown two new buildings and was ready for a third: a

new gymnasium and manual arts building erected in 1910 that would house Lewiston's junior high school from 1914 to 1959.

George Bernard Shaw called civil disobedience "the rarest and most courageous of the virtues." In that context, the risky actions of M.L. Johnson and his disgruntled students in 1888 still echo in every classroom and find their legacy across the city in proud, safe, productive and happy schools.

A GIRL WITH GRIT AND GOOD SENSE

"In my opinion, Mary is the girl to tie to." That's the sentiment that appeared in the article "Women in Great Demand," which appeared in the *New York Times* on December 26, 1886. It was not unusual to find women who owned flocks and herds, but they hired out to men for roundups and shipping. Mary possessed "the grit and good sense" uncommon among the majority of men of her time.

One day in the fall of that year, Lewiston's Mary Markher took matters into her own hands and managed the shipment of four hundred head of cattle to Walla Walla and then to the Chicago market, selling her stock "at a fine figure, and is very proud of the transaction all the way through, as she has a right to be." She was said to have received $10,000 ($252,000 today) for her herd and was planning to ship another four hundred head in 1887.

ENCLOSED: ONE BABY CHICK

The U.S. Post Office inaugurated parcel post delivery on January 1, 1913, and found the program very popular. Later that year, the post office added a "collect-on-delivery" program. On February 19, 1914, Charlotte May Pierstorff's parents, John and Sarah, who lived in Grangeville, wanted to send her to visit with her grandparents in Lewiston, but the $1.53 ($35.00) train fare seemed too expensive. They noticed that there were no provisions in the parcel post regulations specifically prohibiting sending a person through the mail.

So they decided to "mail" their little five-year-old May, who weighed forty-eight and a half pounds, just under the fifty-pound limit for parcel post. The postage, 53 cents ($11.97) in parcel post stamps, was attached

to May's coat. The shipping agent labeled her as a "baby chick." May traveled the entire trip to Lewiston in the train's mail compartment and was delivered to her grandmother's home by Leonard Mochel, the mail clerk on duty. Later that year the post office banned any further human cargo.

May's story was unknown to the public until the publication of Michael O. Tunnell popular children's book *Mailing May* in 1997, ten years after her death.

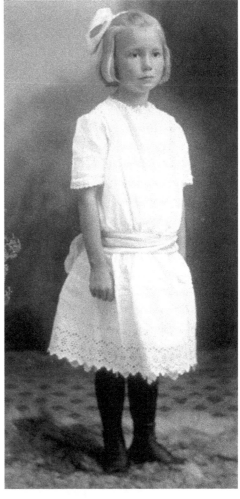

Right: Charlotte May Pierstorff, circa 1914. *Courtesy of Gerald Sipes.*

Below: Fifth and Main Streets, circa 1898.

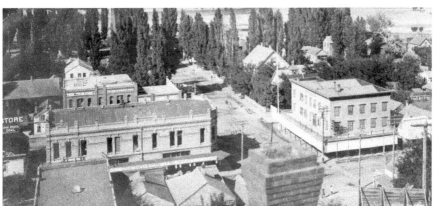

A LANDMARK OF A FADED PAST

The intersection of Fifth and Main Streets was, until after World War II, the economic center of Lewiston. Vollmer had converted his Great Bargain Store by 1904 to house his Lewiston National Bank. Across the street is the Raymond House. Behind the hotel is old Stanislaus Church and St. Aloysius Academy. Notice the sign for the *Lewiston Tribune*.

A Matter of Birthright

Leaving home in a sense involves a kind of second birth in which we give birth to ourselves.
—*Robert Neelly Bellah*

Many Lewiston residents are surprised at the number of important people in many walks of life who were born in Lewiston. While the ol' town may not have been able to keep them "down on the farm," Lewiston was and has always been a part of their heritage. Here is a sampling.

A Pioneer of Modern Technique

Karen Tuttle was born in Lewiston in 1920 and left school after the eighth grade to pursue the violin, having convinced her mother to home school her if she agreed to practice four hours a day. Tuttle also played at a local funeral home to make money for her lessons. After leaving Lewiston, her career led her to several important posts. She pioneered the "coordination" technique, which emphasizes being comfortable while playing the instrument. Originally a violinist, she almost gave up the instrument after developing physical problems from constant playing. She chose to become a violist because of the influence of William Primrose, whose style she saw to be seemingly effortless. In 1950, she was chosen by famed maestro Arturo Toscanini as the

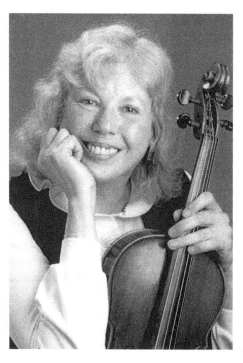

first women to play for the NBC Symphony Orchestra.

She was a frequent participant at the Marlboro Music Festival in Vermont. Tuttle performed several times with famed cellist Pablo Casals. She made her Carnegie Hall recital debut in February 1960 and was a member of the Galimir, Gotham and Schneider Quartets, as well as the American String Trio. In 1994, she was recognized by the American String Teachers Association with the Artist Teacher Award. She taught at the Peabody Conservatory of Music, Curtis Institute of Music and Juilliard. Tuttle died in 2010.

Karen Tuttle, circa 1985. *Courtesy of the Curtis Institute of Music, Philadelphia, Pennsylvania.*

A "WELL-TEMPERED" DISCIPLE

Born in Lewiston on January 31, 1947, Craig Smith began studying the piano at age four. His parents were not musically inclined but did everything to encourage his talents. After graduating from Clarkston High School in 1965 and a brief stint at Washington State University, he moved to Boston in 1967 to attend the New England Conservatory of Music. There, he founded Emmanuel Music in 1970. The group was dedicated to performing the cycle of 224 sacred cantatas of J.S. Bach.

During his association with Emmanuel Music, Smith conducted hundreds of concerts of Bach's works, as well as the United States premieres of several operas by Handel. In 1988, he was invited to be permanent guest conductor at La Monnaie, a Baroque-era opera house and theater in Brussels. He was on the faculty of the Boston Conservatory from 1993 to 2000 and taught at the Massachusetts Institute of Technology, Boston University, Juilliard and the Tanglewood Music Center. Smith died in 2007.

A FAMILIAR FACE ON THE SCREEN

Ray Hyke graduated from Lewiston High School in 1935, having been active in the drama program, and attended Lewiston State Normal School and the University of Idaho. He was stationed with the navy at Pearl Harbor, Hawaii, when the Japanese attacked in 1941, and his appearance in a U.S. Army documentary directed by John Ford led to an acting contract. His first major film was *The Best Years of Our Lives* (1946), which won the Academy Award for Best Picture.

Hyke also appeared in *Red River, Fort Apache, She Wore a Yellow Ribbon, Mighty Joe Young, Three Secrets, What Price Glory?* and *The Beast from 20,000 Fathoms*. Roles on TV included episodes of *The Adventures of Ozzie and Harriet, The Cisco Kid, The Adventures of Wild Bill Hickock* and *Route 66*. He also directed and produced several television programs. He retired from acting in the 1950s and died in 1982.

GOLDEN VOICE, GOLDEN HAIR

Even when she was singing in the Lewiston High School glee club, Betty Jean (Anne) Bollinger was special. She was the daughter of William and Ella Bollinger, the builders and proprietors of the Bollinger Hotel. After graduation in 1937, she studied music at the University of Idaho for a time and then transferred to the University of Southern California at Santa Barbara to work under the tutelage of famed German soprano Lotte Lehmann.

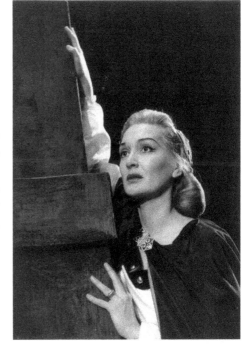

Anne Bollinger, in Giuseppe Verdi's *Aroldo*, 1952. *Courtesy of Robert Bollinger Nielsen.*

After making her professional debut at the Hollywood Bowl in 1944, she came to prominence in March 1948 singing in Bach's *St. Matthew Passion* in Boston under Serge Koussevitzky. She joined the Metropolitan Opera Company in New York City in January 1949, with a contract that lasted until 1953. Her studies then took her to Europe, where she joined the Hamburg State Opera Company. She was featured in performances throughout Europe.

Bollinger went into semi-retirement after her marriage in January 1956 to Jack Nielsen, vice-president of the European division of the Shell Oil Company. Her last visit to Lewiston was in early 1962, when she gave concerts at Lewis-Clark Normal School (now Lewis-Clark State College). Sadly, she was already suffering from throat cancer. She died on July 11, 1962, in Zurich, Switzerland.

A LANDMARK OF A FADED PAST

William Bollinger began his business career as a butcher and general store clerk in Dayton, Washington. His first independent business venture was the Royal Restaurant, which he opened in Lewiston in 1896. In 1900, he opened the Bollinger Hotel as a ten-room establishment, enlarging it in several stages

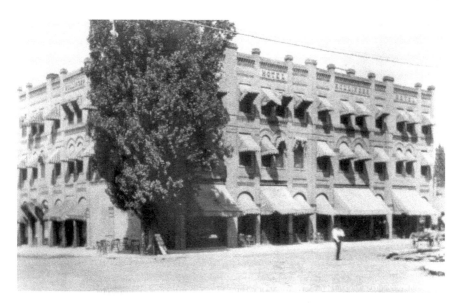

Bollinger Hotel, 1905.

until 1907, when he turned over management to James B. McGrane to enter real estate and insurance. In May 1920, he resumed control of the hotel. Bollinger amused visitors with the "zoo" he maintained, especially bears, until the animals continued to get loose and roam the hallways. For many years, the hotel contained the bus depot. On June 18, 1997, the old hotel burned to the ground.

EARNING A LIVING BY TAKING THE RISKS

Veteran motion picture and television stuntman Don Happy was born in Lewiston on August 14, 1916. He was a patriarch of an active family. Happy appeared as a stuntman for Audie Murphy in five films, including *Gunsmoke* and *Ride a Crooked Trail* and was a stand-in for many stars in the 1940s and 1950s. Happy died in 2006 at the age of eighty-nine. His son Clifford followed him into the movie business, appearing in *Lonesome Dove, Dukes of Hazzard, U.S. Marshals* and *Men in Black II*. Clifford's wife, Marguerite, and sons Ryan and Sean have appeared in many films as well.

TWO BEAUTIES WITHOUT VOICES

Olive Hasbrouck appeared in forty-eight films, mostly westerns, between 1924 and 1929. She has been described by screen historians as nearly every silent western star's favorite leading lady. A redhead, the five-foot-three Hasbrouck acted in vaudeville before moving to films. A very pretty but limited actress, she never really enjoyed a following outside the B-Western genre, despite appearing in such popular mainstream films as *The Cohens and Kellys* (1926). Like many silent-era stars, she retired from films at the advent of sound. She was born in Lewiston on January 23, 1907.

An auburn-haired beauty, silent-film actress Rosemary Cooper was also a Lewiston girl, born here on January 1, 1898. She spent her first years in Hollywood with stock companies. From 1923 to 1928, she appeared in fourteen films, including *The Mailman* (1923), *Closed Gates* (1927) and, most notably, *The Return of Boston Blackie* (1927), in which she had a starring role.

She retired from films when all of the big studios switched to sound in 1929. In March 1943, she became the first wife of the then unknown, and much younger, Howard Keel, who would become one of the biggest stars of MGM musicals in the 1950s.

IT REALLY IS ROCKET SCIENCE

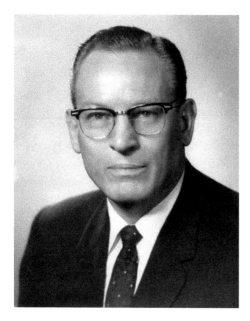

Eugene Root. *Courtesy of the National Academy of Engineering.*

Eugene Root was the president of Lockheed Missiles and Space Company when the firm began its cooperation with the air force space program. Root committed the total resources of the company to the Corona Project, a top-secret spy satellite system operated by the CIA from 1959 to 1972.

Born in Lewiston in 1910, Root helped design aircraft for the Douglas Corporation in the 1930s and 1940s, where he worked to improve the famed DC-3 and Dauntless dive-bomber. In 1955, he guided Lockheed as a major contributor to the Polaris submarine missile defense system. He was a charter member of the RAND "think tank" and was the cofounder of the American Institute of Aeronautics and Astronautics. He died in 1992.

BOM, BA-BA-BOM, BA-DANG-A-DANG DANG, A-DING-A-DONG DING

"Rock 'n' roll has nothing to do with a generation gap anymore," Donald York has said. "Today, it's really a generation bridge." Donald

("Donnie") York may not be a familiar name to many Lewiston residents, but the rock band he helped found certainly is—Sha Na Na, a group of Columbia University friends whose retro style has lasted for more than forty years. Donnie was the one behind those cool shades. In 1970, the group appeared at Woodstock. The group taped ninety-seven episodes of the band's musical variety shows from 1977 to 1981, which can still be seen in syndication. Sha Na Na appeared in the 1979 musical *Grease* as "Johnny Casino and the Gamblers" and contributed to the original music score with six versions of rock classics and one original song, "Sandy," cowritten by band member Scott Simon for John Travolta to sing. He was born in Lewiston on March 13, 1949. His father, Wayne, was the first principal of the then new Whitman Elementary School.

SUPPORTING VICTORY

Born in Lewiston on November 1, 1897, Kester L. Hastings graduated from West Point in 1918. He joined the Third Infantry Division as part of Germany occupation forces in 1919. After various other assignments, he was transferred to the Quartermaster Corps in 1934. In the fall of 1940, he joined the Construction Division, Office of the Quartermaster General, where he was in charge of the operational construction of camps and industrial facilities in the United States.

In May 1949, Hastings became quartermaster of the Far East Command and was stationed in Tokyo, Japan. During the Korean War, Hastings was responsible for planning air drop of supplies to United Nations troops, oversaw the repatriation of remains of servicemen and expedited the supply of food, clothing, petroleum and other materials to the combat forces. He was awarded the Silver Star for personal gallantry in Korea. In October 1952, he was named as the deputy quartermaster general. Major General Hastings became quartermaster general on February 5, 1954.

He retired after thirty-eight years of service in 1957 at the end of his tour as quartermaster general. Hastings died in 1984 and is buried in Arlington National Cemetery.

AN IVY LEAGUE LEGACY

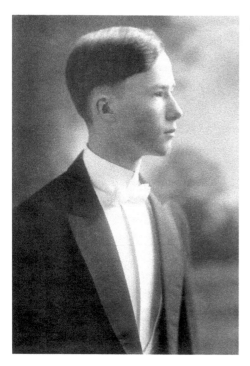

James T. Babb, circa 1914.

James T. Babb was born in Lewiston in 1899, the son of attorney Elisha Babb and his wife, Daisy. James graduated from Yale in 1924. He decided against a law career and eventually would serve as the university's librarian for nearly thirty years, during which he added 3.4 million items to the collection. In 1961, Jacqueline Kennedy asked Babb to oversee a committee that would select books for the White House library. In 1963, 1,780 were placed on the shelves.

When Babb retired in 1965, the Yale Library was the second-largest university collection in the nation. One colleague described his work as "destined to make Yale distinctive and great, a place of superlatives in the world of books." In his career, he raised more than $30 million in monetary funds and $20 million in donated books, papers and collections.

SO MANY STORIES TO TELL

Shirley (Butler) Wood was copublisher and coeditor of the *Block Island (Rhode Island) Times*. Born in Lewiston in 1924, she attended Smith College and joined *Time* magazine as a researcher in the business news department in 1954. She later became a chief researcher for Time-Life books and Time, Inc. Also known professionally as Shirley Estabrook (from her marriage to Ted Estabrook, a producer and director whose technical innovations helped shape the look of early television), she also worked on the staff at *Fortune* magazine.

Wood was assistant news editor with the team that created *People* magazine in 1974. With her husband, Peter, she later moved permanently to Block Island, where they bought the local paper, which they upgraded from a summer publication to a year-round weekly while working as editors. She also owned a real estate agency. She died in the crash of a New England Airlines commuter plane in 1989. Her three daughters have achieved notoriety as a surgeon, an aerospace engineer and an art conservator.

SMALL-TOWN GIRL GOES HOLLYWOOD

Gladys Camille Sorey was born in Lewiston on September 6, 1913. A member of the Lewiston High School class of 1931, Camille became known professionally as Julie Gibson. She sang with the Jimmy Grier Band and dubbed the singing voices for Diana Lynn and Betty Hutton in a couple of movies for Paramount. She first appeared on the screen in *Nice Girl?* (1941). Later movies included *Going My Way* (1944), with Bing Crosby, and *Beat the Devil* (1953), starring Humphrey Bogart, as well as appearances with the Three Stooges.

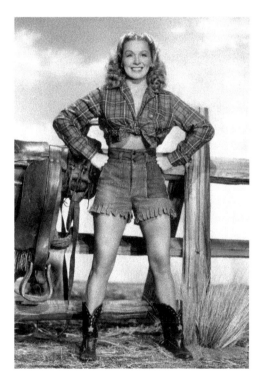

Julie Gibson, 1943. *Courtesy of Paramount Studios.*

Gibson returned to Lewiston in 1944 to be the Roundup Queen. She spent a number of years in Europe dubbing English voices for French and Italian films. She was the dialogue supervisor for the popular TV sitcom *Family Affair* in 1970–71 and was the unit publicist for John Huston's Academy Award–winning *Moulin Rouge* (1952). Her last acting role was in the critically acclaimed TV miniseries *The Awakening Land* (1978). Her

second husband, Oscar-winner Charles Barton, was a principal director of Abbott and Costello comedies, moving to the Disney Studios to direct *The Shaggy Dog* and *Toby Tyler*.

FROM THE FRONTIER TO THE SILVER SCREEN

Colin Collings was born in Lewiston on April 13, 1886. As a young man he became a stage actor, taking the name of Colin Chase, and eventually began appearing in motion pictures, becoming Idaho's first marquee star. His film career started in 1915 with *Fathers and Boys*. He played scores of villainous roles, often in westerns, in which he was often credited as Bud Chase. Chase was a busy supporting player, especially with 20th Century Fox, and had no trouble adjusting to the demands of sound pictures. He eventually appeared in forty-five motion pictures, most notably *King of Kings* (1927), *The Iron Horse* (1924) and *The Plainsman* (1936). He died in Los Angeles in 1937.

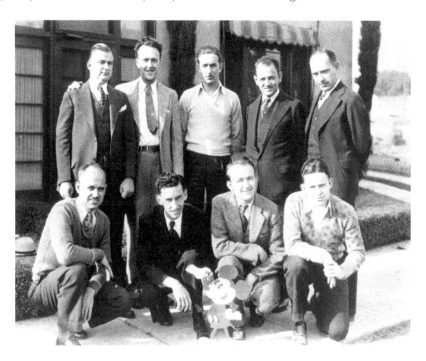

Merle Gilson (kneeling, second from right), 1930. Walt Disney is standing behind Gilson's right shoulder, with Academy Award-winning cartoonist Ub Iwerks to Disney's right. *Courtesy of michaelbarrier.com.*

MICKEY AND OSWALD'S FRIEND

Born in Lewiston on August 23, 1903, Merle Gilson was a cartoonist for Walt Disney Studios from the earliest days of the company. He left Disney to work for Walter Lantz (of Woody Woodpecker fame) twice in the 1930s, the second time in 1938–39, when he received on-screen credits for several animated cartoons, including *Baby Kittens* and *Problem Child*. He was a chief animator for Oswald Rabbit shorts.

Gilson attended the University of Idaho, where he was pledged to Phi Gamma Delta. After he retired, Merle moved back to Lewiston and would draw personalized cartoons of Mickey Mouse for local children. He died on August 28, 1989.

A LEADER IN THE HOME STRETCH

Born in 1884 on the family's ranch in upper Tammany, Owen Mounce started riding early and made his debut as a jockey at the age of thirteen. His first races were at the Lewiston and Spokane racetracks. "The Willows," as the east Lewiston track was known, was one of the best in the Pacific Northwest. By age seventeen, Mounce was considered one of the nation's outstanding riders. He was signed to a contract by August Belmont (of Belmont Park fame), with a guarantee of $7,000 ($178,000 today) for six-months' service and the freedom to ride as an independent when not assigned a Belmont mount.

He was the first to ride the famed horse Yankee Maiden, from the Harry Payne Whitney Stables. At the height of his career, Mounce rode 155 winning mounts in a period of ninety days, averaging six races a day. He quit the sport in March 1902. After returning to Lewiston, he became active in civic affairs and served a term as Nez Perce county commissioner. He died in 1949 of typhoid while traveling in Mexico.

3

THAT ABYSS WHERE
SIGHT IS LOST

...All that tread
The globe are but a handful to the tribes
That slumber in its bosom.
—*William Cullen Bryant, "Thanatopsis"*

While no valid mortality rates exist, historians estimate that at least twenty thousand people died along the Oregon Trail, a ratio of one to seventeen pioneers to start the journey, leaving an average of one grave every five hundred feet on the route between Missouri and the Williamette Valley of Oregon, with mothers, children or husbands often wrapped in family quilts and placed in shallow pits marked with rudimentary cairns. An editor at *Harpers's New Monthly Magazine* commented in 1854, "There ever has been, in all places, in all ages, among all classes and conditions of mankind, a deep-feeling in respect to the remains of our earthly mortality." That being said, the late nineteenth century witnessed a dramatic shift in how the disposal of America's dead was managed.

Whether because of better medicines, improved childcare or improved nutrition, mortality rates began to fall in the latter half of the nineteenth century. All advances aside, few communities could honestly lay claim to being healthy places. In 1870, a child had only a 50 percent chance of living to the age of five. Children were subject to cholera, smallpox, measles and all of the other adult diseases, but childhood intestinal diseases were the most terrifying. Infants would become diarrheal, then dehydrated and die. A study of the child mortality statistics for Chicago yielded a death rate of

285 per 1,000 live births in 1870 and 236 per 1,000 births in 1880. Some headway was being made.

Lewiston suffered the same scourges in its early years. Local promoters bragged about the healthful climate, but weekly newspaper columns catalogued extensive lists of those suffering with ailments. While the Lewiston board of health was roundly scolded for allowing pools of stagnant water along streets, few objected to the shallow wells from which many residents drew their water until the late 1880s, when the city fathers finally addressed the problem of wells placed along the base of the bluff atop which the town had been burying its dead for twenty-five years. The water was seeping through the graveyard. A cemetery up-gradient from a town or its water supplies (especially wells) will produce repeated and widespread illness. Contagion in any form was to be feared in an era that knew nothing of antibiotics and depended on medical sciences that had yet to develop a shared and uniform opinion about the existence and effect of germs. Nearly half of all recorded deaths in Lewiston during the 1880s were among children under the age of ten. One such child—Evangeline Vollmer—will be part of our story. All the risks of accidental injury and the consequences of violence aside, it was a dangerous time for young and old alike.

Several regional outbreaks of smallpox created panic in the fledgling communities of southeastern Washington and northern Idaho. Quarantining a patient or his immediate family was not an adequate solution; whole towns were shut off from the outside world, without stage or mail service. In November 1881, Dayton, Washington Territory (WT), was quarantined. Mail from Lewiston bound for Portland had to be rerouted north through Colfax, WT. In December 1881, the threat of smallpox came closer to Lewiston. Five deaths were reported on the north side of the Clearwater River among the Nez Perce: "They all occupied one lodge. All the other Indians fled from the vicinity upon the first outbreak. An Indian woman brought the scourge from Colfax." In Lewiston, there was talk of using the old Luna House Hotel building as a smokehouse, where travelers suspected of bringing in smallpox could be disinfected.

A Lewiston newspaper offered a home cure of "one grain of sulphate of zinc and one grain of foxglove or digitalis, mixed with a little water and sugar." The patient was to be given a tablespoon every hour. A cure was predicted by the eighth hour: "If any of our physicians have employed this remedy with success, let them say so to the public. It may confer a blessing upon such as cannot procure a physician." There is no record of any response. The newspaper continued with recommendations for sealing

the house with sheets soaked in "carbolic acid, chloride of lime or Condy's fluid," a potassium permanganate solution still used as a disinfectant. Finally, the house had to be disinfected. The ceiling was whitewashed and the paper stripped from the walls and burned. Furniture was washed with soap and water and chloride of lime.

If smallpox was not enough, territorial doctors had to contend with diphtheria, typhoid and even "la grippe" (or pandemic influenza). Diphtheria was especially feared, as whole families could be wiped out. Lewiston had its years of epidemics when schools and churches were closed. Diphtheria would haunt Idaho for many years to come. Not long after World War II, scores of typhoid cases were reported in and around Boise. And yet, not every malaise was germ-based.

The Civil War traumatized Americans with its unprecedented slaughter, not to be relived until the abject butchery of the western front in World War I. For instance, on the morning of June 3, 1864, at Cold Harbor, Virginia, mass gunfire killed or wounded an estimated seven thousand Union troops within the first twenty minutes of a futile bayonet assault on strongly entrenched Confederate lines. Thousands of men would survive their grim duty, only to return home with a "soldier's heart," what today is diagnosed as post-traumatic stress disorder. Many a man came to the American West haunted by vivid and ghastly images. Countless veterans, Union and Confederate, relocated

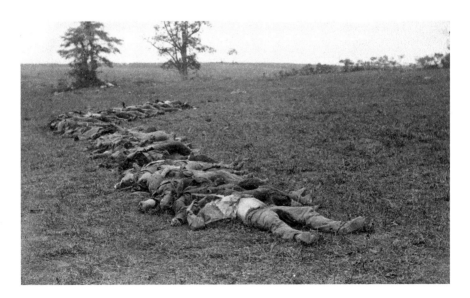

Confederate dead at Antietam, September 1862. *Courtesy of the Library of Congress.*

after 1865. More than one thousand can be documented as having resided in Idaho, many living out their lives and being buried in the state.

No less demoralizing was the widespread lack of closure for the families who suffered through the losses of fathers, brothers and sons on distant battlefields, without the customary rituals of family preparations of the body and interment. Ralph Waldo Emerson observed, "The chief mourner does not always attend the funeral." Soldiers died clutching photographs and letters from home or with notes pinned to their tunics like dog tags in hopes of aiding the return of their bodies to their loved ones. A recovery team reportedly found a blood-spattered diary on the body of one Union soldier. His final notation read: "June 3. Cold Harbor. I was killed." During the conflict, embalmers prepared the bodies of thirty to forty thousand Union dead in tents and makeshift mortuary sheds, readying them for shipment home—most often at a cost of $7 ($130 today) for an enlisted man, $13 ($240 today) for an officer. At first, wooden coffins were used; however, when shipping delays mounted and delivery times lengthened, resulting in unbearably foul arrivals, sealed metal coffins were soon required.

Prior to the twentieth century, most families cared for their own funerals. As late as one hundred years ago, fewer than 15 percent of Americans died in hospitals. With the advent of America's "modern war," local newspapers began to carry ads for a new town professional: the undertaker and embalmer. A brief historical overview of the prevailing funeral practices and movements will provide some context.

Cemeteries as we have come to accept them today did not appear until 1831, when Mount Auburn Cemetery was opened in Cambridge, Massachusetts. Mount Auburn's design proved a distinct departure from the church graveyards that were a European legacy for American towns and cities. Within thirty years, rural cemeteries replaced churchyards altogether. In 1836, James A. Gray was issued the first patent for a metal coffin, which was improved by A.D. Fisk (1848) and A.C. Barstow (1859). Lewiston set aside an area for a city cemetery by 1863, a mere two years after its founding and well before any church was built. As we have seen, this created silent, lingering health problems by ignoring the dangers of its proximity to town.

Burial grounds slowly began to resemble today's cemeteries after 1855, when Adolph Stauch created Spring Grove Cemetery in Cincinnati, Ohio. The "lawn-style" cemetery pattern would be replicated across America. The U.S. War Department, as part of its expansion of the cemetery system, created a national cemetery at Fort Vancouver in 1875 to hold the remains of soldiers buried at abandoned posts in the territory. Idaho had no similar provision.

The first formal organization of undertakers—the Undertakers Mutual Protective Association—was founded in Philadelphia in 1864, a direct result of the war. Dr. Julius LeMoyne opened the first American crematorium in Washington, Pennsylvania, in 1876. On January 14, 1880, a group of twenty-six Michigan undertakers held the steering meeting of what would be established in 1882 as the National Funeral Directors Association (NFDA). Soon after, the organization made a concerted effort to replace the word "undertaker" with "funeral director." Practitioners appropriated the term "parlor" because of its private-home connotations. Death was slowly assuming the trappings of an industry.

The first full-service funeral home in the United States opened in 1885 in Philadelphia. Idaho waited until 1903 for an "exclusive mortuary"—C.J. Vassar Undertaking & Embalming, in Lewiston. During the nineteenth century, services were most often conducted in the home of the deceased. The undertaker brought all the supplies and equipment. If embalming was performed, it was carried out in the home. Religious services were held at the home or in church, after which the funeral concluded with a procession to the cemetery. Among the undertaker's assignments was to remove all signs of the funeral from the home while the family attended the procession and interment so that the family had no work to do upon returning. The undertaker cared for the construction of the coffin and provided some basic assistance. Indeed, most undertakers were cabinet and furniture makers by profession and morticians by opportunity. The first professional training courses for morticians commenced in 1882 at C.M. Lukins's Cincinnati School of Embalming and Dr. August Renouard's Rochester (New York) School of Embalming. And embalming is an important part of this story.

Unlike Cincinnati's Spring Grove, Lewiston's city cemetery was a primitive plot, ungroomed and ill protected, out of sight from the town's business district and residential neighborhoods. A visitor in July 1884 described the area as "wheat fields and desert." Lewiston's population soared to about two thousand by 1863; but the gold rush faded, and the town settled with a census of about eight to nine hundred until the 1890s. Four physicians had hung out their shingles in the early tent city, which would have a small infirmary within a year. With Lewiston in the role of the territorial capital—at least for a while—it proved to be a heady time for a town slowly outgrowing the sobriquet "rag town," where life and death played out as in any other community. Given the period's mortality rates, twenty to twenty-five townspeople would have died each year.

The first mention of a Lewiston burial dates from the spring of 1864 and involved both a famous frontier murder and a few fragments. Lloyd Magruder supplied materials and provisions to the mining towns of the inland West. A group of "ruffians" posing as helpers killed him and four companions in October 1863 along the trail from Lewiston to Virginia City, Montana, dumping their bodies into a deep ravine for animals to devour. After the culprits were hanged in Lewiston the next March, a recovery team journeyed to the scene of the crime and discovered a few bones, a few buttons from Magruder's coat and some firearms. The party reported that the scavengers had left little else. They gathered what they could find of "the remains of the unfortunate victims, which were decently buried in the cemetery at Lewiston." Magruder's reputation and the notoriety of the case likely resulted in well-attended interments in today's Pioneer Park, all of which were sadly never marked.

Lewiston had no undertakers before the 1880s. Few, if any, Idaho towns did. Those who wished to bury a loved one in a beautiful coffin sought out the best carpenter in town and hoped he could build one quickly. Without embalming, burials were quick affairs, usually the day after death. One enforced Lewiston burial occurred the same day, when the thermometer read 111 degrees Fahrenheit (43 degrees Celsius) in the shade. The distinction of being Lewiston's first advertised undertaker would go to John B. Menomy, skilled carpenter and civic leader, who opened his shop on Main Street by 1884. The profession was in such a state of infancy in the territory that the March 1888 Sanborn Company map of the street labels Menomy's establishment (next door to the home and office of Dr. Henry Stainton) as "carpr." or one-story carpenter's shop, with a dwelling attached and a cellar in the rear, set into the hillside. Before Menomy identified himself as an undertaker, the firm of Hale & Cooper, a local mercantile company, advertised the availability of "every quality of caskets and coffins with their trimmings ready made." Carpenters had competition. Within a month of Menomy's opening, Hale & Cooper announced plans to sell their furniture shop and become undertakers. Two years later, the company announced the purchase of "an elegant hearse, the cost of which was over $1,200" ($30,000 today). By the 1890s, Lewiston had several undertaking storefronts.

Nineteenth-century embalming has since proven to be problematic for archaeologists. Far from their peaceful appearance, cemeteries can harbor several contagions, quite aside from the biological terrors that concern pulp fiction writers. Fort Reno, a popular park in Washington, D.C., was closed to the public in May 2008 after elevated levels of arsenic dating

from the time of the Civil War were detected in the grasses and trees of the location. The National Park Service closed the park within twelve hours after investigators isolated the pollutants. Procedures in the latter half of the nineteenth century regularly included the widespread use of an arsenic trioxide solution (arsenous acid) of varying strengths depending on the expertise and preference of the embalmer. Arsenic was preferred because large doses controlled bacteria and postponed putrefaction. Some contemporary recipes called for as much as twelve pounds of arsenic per corpse.

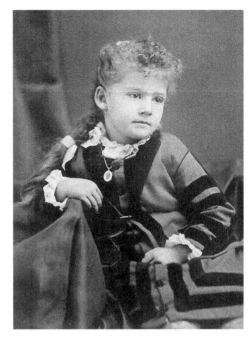

Evangeline Vollmer, 1881. *Courtesy of the John P. Vollmer Family Archives.*

The use of arsenic killed so many undertakers that it was banned in the United States by 1910. Arsenic sickens and/or kills by blocking essential metabolic enzymes, and the victim suffers multisystem organ failure. Morticians benefited from the ban, but the deleterious effects of arsenic on the environment of a cemetery are only lately the subject of scientific inquiry.

It was in this context that an eight-year-old girl sickened and died, providing us with a well-documented case study of a "proper" funeral in the early 1880s.

Evangeline Vollmer was born on Tuesday, November 19, 1872, the first child to John and Sarah Vollmer. Her father was an entrepreneur who would, by most accounts, eventually become Idaho's first millionaire. Evangeline was a privileged child, one whom an editor of the *Lewiston Teller* later called "the child whose innocent sweetness had for years found expression from the lips of all who knew her."

In early September 1881, Evangeline became ill. Dr. Henry Stainton visited the Vollmer home four times on the eleventh and once again on the twelfth and fourteenth, presumably tending to what would be listed for a

cause of death as "malarial-typhoid fever," an illness common in obituaries of the time. Serious illness had been no stranger to the Vollmer home. In April 1875, John grew so weak that, according to one report, he was "almost despaired of." His malady was described as a "hybrid" combination of measles and scarlatina (a form of scarlet fever), much the same as in an outbreak in New York City in 1873. Given the seriousness of the disease, his recovery is remarkable. Sarah was very ill for more than a week in 1878, but no mention remains of what condition she had developed.

The actual cause of Evangeline's sickness and death is debatable. Dr. Stainton based his diagnosis on reports relating to "camp diseases" during the Civil War. The term "typho-malarial" first appeared in field reports in June 1862. In Evangeline's case, malaria was not the problem. Lewiston's latitude at N 46.4° precluded that, but typhoid was certainly a factor. Typhoid was a constant killer during the Civil War and stalked America's cities. The ailment Dr. Stainton faced was described in medical texts as "often difficult to manage, lengthy in duration, and frequently fatal." A blood test and antibiotics would be prescribed today. It was not so simple in 1881.

Salmonella typhosa (typhoid fever) can only attack humans. So the infection always comes from another human, either an ill person or even a healthy carrier of the bacterium, Mary Mallon ("Typhoid Mary") being a notable example. The contagion is passed on with water and foods and can withstand both drying and refrigeration. Children exhibit the symptoms of typhoid very rapidly, albeit in a milder form. People first suffer from fever, the highest usually in the evening. Patients become weak and often complain of stomach pains, headaches or loss of appetite. In some cases, they may have a rash of flat, rose-colored spots. Left untreated, typhoid enters its second stage after seven to ten days. Stainton returned to the home on September 24. By this time, Evangeline was gravely ill. He would now be in attendance every day.

Physicians—certainly Lewiston's—had few effective medicines for typhoid. The most popular remedy was "salicylic of soda," given in an effort at the very least to bring down the accompanying fever. If ineffective, the fever soon became continuous; vomiting and diarrhea accelerated dehydration. Bronchitis commonly set in. In the third week, intestinal bleeding, a dramatic drop in blood pressure and shock occurred.

Sadly, Sarah and John kept no diaries to speak for them of that terrible month, and especially for the morning of what was their eleventh anniversary. Like any devoted mother, Sarah must have spent another sleepless night with her failing daughter. Whatever the contagion, dehydration would have forced Evangeline into the "typhoid state," motionless, eyes half-closed, appearing

wasted. She had struggled as much as her small, eight-year-old body would allow. Evangeline died at 7:00 a.m. on Tuesday, September 27. In keeping with the etiquette of the nineteenth century, the mirrors would have been covered with black crape. Her photographs were turned face-down, and the clocks were stopped at the time of death. Crape was tied with a white ribbon to the entry doorknob, signifying that a child had died within.

Stainton returned to the Vollmer home in the evening for an extended visit. With a sad determination, John and Sarah Vollmer promptly set themselves to a parent's saddest task. Evangeline's body was lovingly washed and prepared by family friends in a time-honored ritual currently undergoing a renaissance of popular interest. John called on his new Episcopal minister, Reverend J.D. McConkey, to conduct the service. John circulated a hastily printed but tasteful notice the very day of Evangeline's death, inviting the town, "especially children," to the funeral at 2:00 p.m. on Wednesday. Following the protocol of the time, "very near relatives are exempted by their affliction from attending the funeral, but all others who are notified of the loss should be present." Whether Dr. Stainton embalmed Evangeline the evening of the twenty-seventh will never be known. However, prevailing health regulations stipulated the need of proper embalming for cases of typhoid.

For those who could afford the expense, funerals were highly stylized occasions. A popular manual for all occasions outlined the procedures:

> *The gentleman who undertakes the management should ask a lady friend to make the purchases necessary for the family previous to the funeral, as he cannot be expected to understand their wants, in such particulars, and none of the household actually bereaved should leave their home for any purpose, from the time of the loss, until after the funeral cortege, save male members of the family.*

Guests were not to arrive early to the funeral. A family friend acted as intermediary between the family and callers, who left their cards.

> *During the hour that the service may last, you must drive from your mind the ordinary cares of life; if your friends are there, a silent pressure of the hand may be your only recognition, and should enemies be present, whom you would not recognize, subdue your animosity in the presence of the Great Conqueror, and salute with respect.*

A young boy lies in state, circa 1905. *Courtesy of Vassar-Rawls Funeral Home.*

The Episcopalian congregation had only recently accepted the generous use of the new Universalist Church building at Seventh and Main Streets for their meetings. Friends of the family lovingly decorated the interior with flowers and evergreens, interspersed with crape, to symbolize Evangeline's youth, memory and "future life of the dear departed."

Evangeline was carefully dressed for her funeral.

> *White cashmere robes and flowers are always most appropriate...As for the coffin, it is simpler than formerly; and while lined with satin and made with care, it is plain on the outside—black cloth, with silver plate for the name and silver handles, being in the most modern taste.*

She would have been carried out of the house feet first, in the superstitious belief that this would prevent the spirit from looking back. Her body arrived by carriage and was placed near the altar.

As 2:00 p.m. neared, neighbors arrived in their buckboards, as others walked from their homes along E Street (now Main) and Snake River Avenue

to the Vollmer home. In the late nineteenth century, mourners gathered at the home and moved as a group to the church. Everyone huddled from the weather. It was a cloudy and wet day.

Following the established procedures outlined in his Episcopal manual for local ministers, Reverend McConkey met Evangeline's body at the entrance to the church and led the congregation inside. As he did so, he recited or sang a prescribed order of verses (John 11:25, 26; Job 19:25–27; 1 Timothy 6:7; Job 1:21). The first portion of the service consisted of an "anthem," which was also recited or sung and taken from the Thirty-ninth and Ninetieth Psalms. Evangeline's playmates arose, left their parents' sides among the audience and approached her coffin, filling it with nosegays, little personal bouquets of flowers they had crafted. Customarily, coffins were not open during Victorian church funerals. Evangeline was too popular for ceremonies to be held at the Vollmer house, as evidenced by the sentiments printed in the *Nez Perce News*:

> *The great heart of the community beats in sympathy with the afflicted parents over the irreparable loss they have sustained in the death of their beautiful child. Evangeline was too good, too pure, for this base world of ours.*

The choir sang several "dirges" as the large crowd wept. After McConkey completed his sermon based on 1 Corinthians 15:20–58 and adjourned the services, the mourners gathered up their King James Bibles and emotions and returned to their homes, to reconvene the next day at the Vollmer home for the precession to the cemetery. One can hardly fault the Vollmers if they wanted to be with their daughter one more day. Although no image has ever been found, John and Sarah may have desired to have Evangeline photographed one more time. Postmortem photography of the deceased, especially of children, was an obsession for nineteenth-century Americans. However morbid the practice may seem to our twenty-first-century sensibilities, photographs were a powerful memory aid to grieving parents, siblings and relatives.

Thursday was cool, the high reaching only fifty-two degrees Fahrenheit (eleven degrees Celsius). And it rained off and on during the day. "A large concourse of sorrowing friends" gathered at the Vollmer home and made its slow and quiet trek up the old wagon road to the barren, undeveloped bluff some 150 feet above the town. The pallbearers walked at the sides of the hearse with the minister preceding. The flower carriage was sent ahead because of its tendency to cause delays. Evangeline's carriage

would have been decorated with white plumes, the symbol of a child's funeral, with black for adults.

Upon cresting the hill, the mourners could see the cemetery gates. Lacking a reliable and readily available water supply, and without someone to groom the cemetery grounds, the area quickly turned to brown and wind-blown stubble in the hot Lewiston summers, when temperatures can reach well over 100 degrees Fahrenheit (38 degrees Celsius) for many days at a time. To any modern observer, the graveyard would appear to be little better than an overgrown, neglected pasture. At least the cows and goats had accomplished something to control the grass and thistles. On this wet September day, many a shoe would be caked in the mire of dust turned to slurry. Cockleburs would litter "Sunday-best" trousers and skirts.

Reverend McConkey assembled the mourners at the gates of the cemetery. Again he recited the church's processional for the dead as the group followed him on its way to the site of the burial. As John was a member of the local lodge, he purchased a plot in the Masonic Cemetery to inter Evangeline. Located at the north end of the grounds, the site overlooked the town and the Clearwater River. An open and prepared grave awaited the mourners' arrival.

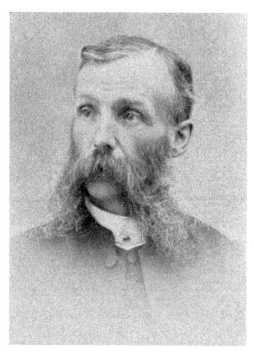

With all assembled, McConkey began by reading Job 14:1, 2: "Man, that is born of a woman, hath but a short time to live, and is full of misery. He cometh, and is cut down, like a flower; he fleeth as it were a shadow, and never continueth in one stay." Dirt was scattered on the coffin during the graveside service and a final prayer was read:

For as much as it hath pleased Almighty God, in his wise providence, to take out of this world the soul of our deceased sister, we therefore commit her body to the

Reverend John D. McConkey, circa 1891. *Courtesy of the City of Portland, Oregon, Archives.*

ground; earth to earth, ashes to ashes, dust to dust; looking for the general Resurrection in the last day, and the life of the world to come, through our Lord Jesus Christ; at whose second coming in glorious majesty to judge the world, the earth and the sea shall give up their dead; and the corruptible bodies of those who sleep in him shall be changed, and made like unto his own glorious body, according to the mighty working whereby he is able to subdue all things unto himself.

Funeral protocols that nineteenth-century families tried to abide by appear to us as excessive, morbid and maudlin:

Mourning for children should last nine months. The first three the dress should be crape-trimmed, the mourning less deep than that for a husband. No one is ever ready to take off mourning; therefore these rules have this advantage—they enable the friends around a grief stricken mother to tell her when is the time to make her dress more cheerful, which she is bound to do for the sake of the survivors, many of whom are perhaps affected for life by seeing a mother always in black. It is well for mothers to remember this when sorrow for a lost child makes all the earth seem barren to them.

Headstones during the late nineteenth century lost many of the skeletons, angels of death and winged skulls so prevalent on earlier markers. Cemetery art became more ornamental, if a permanent stone could be obtained. Even coffin styles were changing. Between the 1880s and 1890s, coffins changed from traditional six-sided "toe-pinchers" to four sided, the shape of a casket today. Pioneer cemeteries were still populated with rough stone or wooden markers. Evangeline's headstone would not arrive for some months. A majority of graves were unmarked. Lacking proper plat maps, most pioneer cemeteries do not have a complete graves registry that corresponds to a ground plan.

In stark contrast with the care and reverence of Evangeline's funeral was the simplicity and frequent anonymity of those buried by friends or at the county's expense. The death and burial of Joseph Mardeaux, an indigent, is a good example. Mardeaux had become a county ward and died in 1877. When the Nez Perce County commissioners convened for their quarterly meeting, a set of bills was submitted for payment from the county hospital fund, a common method to underwrite the county physician, inquests and other health-related expenses. Commissioners approved the payment of

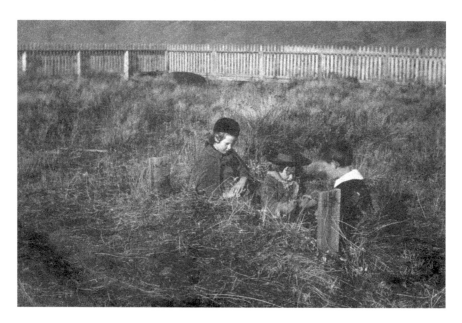

Grave site of Evangeline Vollmer, 1881–82. *Courtesy of the John P. Vollmer Family Archives.*

$43.40 ($925.00 today) to various individuals, since no one person supplied all of the services needed for a "Christian burial":

$23.40: coffin
$6.00: horse and carriage "used in conveying the dead to the grave"
$5.00: digging of grave

On occasion, officials approved payments for new burial clothes. However, their generosity had its limits. In 1882, Dr. John Q. Moxley petitioned for the payment of a bill for carbolic acid, which was listed as a "disinfectant." The commissioners disallowed the claim without comment, although a nine-dollar warrant had been issued for a claim related, it seems, to Mardeaux's death in 1877, at the time when famed English physician Joseph Lister was pioneering the use of carbolic acid for antiseptic surgery. Robert Koch's "Postulates," establishing a clear link between a causative microbe and a disease, were still more than a decade in the future. Apparently, Lewiston's doctors were remaining "current," even if the county commissioners failed to appreciate their efforts. Many readers will be surprised to know that even today it takes seventeen years for medical advancements to make their way into clinical practice.

The town would achieve eventually a hard-won economic stability and flourish as statehood dawned, erect a hospital worthy of its civic pride and draw more health professionals to serve its residents—all in an unknowing anticipation of the terror levied on most of Idaho's towns in 1918–19. The Spanish influenza would prove the mettle of Idaho's medical and mortuary professions. While the state's final toll may never be known, the case of Franklin County is representative. Watkin L. Roe, from the Franklin County *Citizen* newspaper, sent a letter to U.S. surgeon general Rupert Blue to report that the pandemic had affected about 1,300 of the county's 7,500 to 8,000 residents and had killed 31. Projecting those statistics using Idaho's 1920 census figures produces an infected population of more than 70,000, with as many as 1,700 deaths. By October 1918, the spread of the disease to five new cities in Idaho was receiving national attention. The word quarantine would again be levied against entire towns. Challis posted town guards in an illegal attempt to protect itself from outsiders and keep its own residents from traveling. Lewiston's Normal Hill Cemetery holds the remains of at least seven nuns who died while serving as nurses to neighbors and friends struck down by the pandemic, which killed scores of local residents. So great was the loss to St. Joseph's Hospital that a nursing school was founded there in 1919.

Thankfully, Idaho's medical infrastructure was prepared, survived intact and grew stronger and more organized. The funeral customs and social mores had changed—much too quickly for some. Many old cemeteries fell into woeful disrepair as bone fragments slowly percolated into the top soils of the graveyards and became oddities discovered by metal detector aficionados probing for other treasures. The uncertainties and fears of the old days slowly disappeared below the historical horizon as the memories of the frontier adversities grew increasingly dim. On the eve of the First World War, American social reformer Daniel Carter Beard would lament, "The hardships and privations of pioneer life which did so much to develop sterling manhood are now but a legend in history."

So it is in that abyss where sight is lost.

4

When the Trumpets Called and Shouts Filled the Air

He who knows when he can fight and when he cannot will be victorious.
—*Sun Tzu*

Lewiston has been home to hundreds of veterans of conflicts dating from well before Idaho was even a name on maps to today's Afghanistan combat. Volumes could be written. I am forced by space to confine myself to a few individuals and leave it to another historian to write a comprehensive telling.

"Parlez-Vous Français, Mon Ami Polonais?"

The earliest inscribed birth year on a headstone in Lewiston's Normal Hill Cemetery is 1795 and belongs to Moses Grostein, a native of Poland. As a teenager, Moses became enamored of the glory surrounding Napoléon Bonaparte, to whom one resource says Grostein gave "active assistance" as a solder in the Grande Armée during the 1812 invasion of Russia, presumably as a member of V Corps, which was made up entirely of Polish soldiers from the Duchy of Warsaw under the command of General Józef Antoni Poniatowski. It was one of few non-French corps of the Grande Armée and, at its peak in 1812, consisted of around thirty-six thousand Poles.

By 1838, Grostein was no longer welcome in Poland and immigrated first to Georgia and New York and then to Lewiston in 1870 to join his son Robert. He died in 1886.

THE MANIFEST DESTINY GENERATION

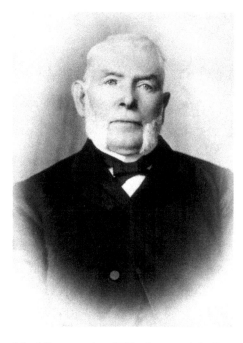

John Menomy, circa 1885. *Courtesy of the City of Lewiston.*

Three veterans of the Mexican-American War (1846–48) are buried in Lewiston.

John Menomy (1826–1889) was one of Lewiston's first undertakers, served several terms as a city council member and was Lewiston mayor in 1885–86. In 1888, he prepared the forty-acre graveyard that became Normal Hill Cemetery. He was a private in the First New York Volunteers.

Moving to Idaho in the early 1860s and a Lewiston resident by 1870, Thelbert Wall had served with Company H, First Regiment, Texas Mounted Volunteers. When the Nez Perce War erupted in the summer of 1877, his buildings and crops on the South Fork of the Clearwater River were burned by Nez Perce warriors. Born in Kentucky in 1820, Wall died in August 1896.

Born in 1828, John Siers served in Company K, Second Indiana Volunteers. Cited for bravery at the Battle of Buena Vista on February 23, 1847, he was often known as "Buena" Siers. He came to the Lewiston area in the 1860s and began a partnership with Joseph Shissler to develop the Waha prairie. After Shissler's death in 1886, he leased land from the Shissler heirs and then lived in the East for a few years, returning in 1894. While the following account would fit well in chapter 5, I will tell it here.

Legal problems quickly arose when Siers returned to reclaim monies owed as part of the lease agreement. The situation was aggravated by Siers's insistence on moving into the new home built on the property. That home is now known as 21 Ranch. A settlement was negotiated, and Siers arrived at about 6:00 a.m., on May 19, 1895, to gather his belongings. He was met at the door by his former associate Frank Ward, whom Siers had dispossessed when Siers returned to Idaho. Words were exchanged. Mrs. Mary Goddard,

a neighbor who had gained control of the property and Ward's mother-in-law, tried to intervene.

Ward fired two shots at Siers but missed. As Siers was going for his revolver, Mrs. Goddard pulled a pistol from her waist, placed the muzzle against Siers's back and fired several times. Ward struck Siers over the head as the victim fell forward, dead. Elmer Shorthill, a Siers employee, shot Ward, who later died of his injuries. Mrs. Goddard was charged with murder, defended by James W. Reid and acquitted after a very expensive forty-day trial, much to the dismay of Lewiston residents, who followed the proceedings very closely.

THE BETTER ANGELS OF OUR NATURE

More than 3 million men and women served in the Civil War (1861–65), which cost at least 620,000 lives. Some scholars now put the total at nearer 750,000 deaths. The Grand Army of the Republic (GAR) was a fraternal organization formed in 1866 by soldiers and sailors who served during the Civil War and was one of the first "special interest groups" to wield political power. Five members were elected president of the United States.

Idaho would eventually have twenty posts, seven of which were in North Idaho. Although Lewiston is listed by some sources as the second post in Idaho, the weight of evidence increasingly shows that Lewiston may indeed have been the first, for the *Los Angeles Times* of March 14, 1882, reported that a post had already been formed in the city as part of the Oregon Department. On January 3, 1883, a slate of officers of the local Rutherford B. Hayes post was installed. George Manning, who fought with the Second Massachusetts Cavalry, was elected the new commander of the post. In June 1882, he had been named as aide de camp to the commandant of the new Oregon-Kentucky Department of the GAR and would be the Idaho Department commander in 1905.

Lewiston's first GAR Hall was located at Seventh and Main Streets, in the old Universalist Church building, which burned down on April 12, 1908, while in use by the local Baptist congregation. Lewiston's last Civil War veteran, William Wolf, who served with the Twentieth Pennsylvania Cavalry, died in 1938. The last Idaho veteran of the Civil War died in 1952.

After the Civil War, thousands of veterans moved out West. Lewiston's Normal Hill Cemetery is the final resting place for more than seventy, both Union and Confederate. A walking guide for the locations of their graves

can be downloaded from lewistonschools.net/staff/sbranting/walking.pdf. One particular warrior from this defining conflict deserves mention here.

John Lane was the son of famed Joseph Lane, territorial governor of Oregon, delegate to Congress and later one of its first U.S. senators. In 1860, Joseph was nominated for vice-president of the proslavery Southern wing of the Democratic Party, as John C. Breckinridge's running mate. Lane County, Oregon, is named for him. In the meantime, John was studying at West Point, where he was a classmate of George Armstrong Custer, living in an adjoining room from the future leader of the Seventh Cavalry.

John resigned from the academy on February 18, 1861, to join the Southern cause. It was not a hasty decision. In a letter to his father, dated December 14, 1860, he wrote:

> *You promised in your last letter that in case of disunion you would take care of me. Whatever arrangements you may make for me be sure they are of a military character. I am bound to be in some army. If I fail in getting a commission in the army of the Southern Confederacy I shall offer my services to Garibaldi [in Italy], in case he begins another campaign & if he does not get into war with Austria then I shall go to Russia. The Army forever. As our country stands at present, I can not serve her with real devotion & patriotism which should characterize a soldier.*

John found a place with the Eleventh Georgia (Sumter) Artillery. Civil War reenactors annually portray his actions at the Battle of South Mountain (1862). Wounded three times during the war, Lane led

John Lane, circa 1875. *Courtesy of Lilly Library (Indiana University Bloomington).*

batteries at Antietam (1862) and Fredericksburg (1862). He commanded the battalion at Gettysburg (1863) and Petersburg (1864). He would rise to the rank of lieutenant colonel. A lawyer after the war, Lane moved to Lewiston in October 1897 to become special U.S. Indian agent. He would recount that the stage on which he rode into Lewiston was stopped at the top of the Lewiston Hill and robbed. In his new role, Lane would renegotiate two treaties in the early 1900s. He died in 1914. His headstone in Normal Hill Cemetery reads, "One of Lee's soldiers."

TWO OF THE CONSPICUOUSLY BRAVE

Two Lewiston residents earned the Medal of Honor for gallantry and are buried here.

Originally from Baltimore, Maryland, First Sergeant Francis "Frank" Oliver enlisted in the First U.S. Dragoons in 1855 in New Mexico and served in California. Soon after the outbreak of the Civil War, his unit became the First U.S. Cavalry. Oliver fought at Cold Harbor (1864), Trevilians (1864) and Five Forks (1865). He was wounded at Smithville, Virginia, in August 1864. Reenlisting after the war, Oliver was posted in the West and was among the members of the First Cavalry who pursued Apache leader Cochise to his stronghold in the

Francis Oliver, circa 1870.

Chiricahua Mountains (Arizona), where, on October 20, 1869, Oliver was cited for bravery in action and won the Medal of Honor, which was awarded to him on February 14, 1870.

He was transferred to Idaho in August of that year. He mustered out of the army on February 3, 1873, at Fort Lapwai. Based on the best evidence, Oliver is still buried in Lewiston's Pioneer Park, where he was laid to rest in July 1880 after dying of an overdose of laudanum, a tincture of opium that he was ingesting to ease the pain of stomach cancer.

A native of Mandan, North Dakota, Richard Longfellow was one of a hand-picked group of soldiers known as "Young's Scouts." This unit spearheaded incursions into rebel-controlled areas during the Philippine Insurrection. On May 13, 1899, eleven of these scouts earned Medals of Honor in a frontal attack on three hundred enemies. Three days later, the scouts clashed with a large enemy force at San Isidro after the insurgents had set fire to an important bridge.

Three of the scouts rushed the bridge, all the while firing at the enemy at close range. The remaining members of the unit took cover and returned fire on the enemy trenches on the opposite bank, which was only fifty yards distant. Longfellow was one of twenty-two scouts who extinguished the flames on the bridge, although there was constant enemy fire. They then turned their attention to the enemy positions and routed the six-hundred-strong Filippino forces.

Longfellow moved to Lewiston in 1922 and retired in 1937 after decades of service to the Northern Pacific Railroad as a conductor. He died in May 1951.

"AVANT, LE CHAR DE MORT" (FORWARD, TANK OF DEATH)

A member of the Lewiston High School class of 1912, Oscar A. Axelson graduated from West Point in 1918. He left the regular army in 1928 to serve with the New York National Guard. Recalled to active duty in 1940, Axelson commanded the 991st Field Artillery Battalion from April 1943 to October 1944. Few units smaller than a division performed as well as did the 991st under his command during the war against Germany

Besides participating in the Battles of Normandy, Northern France, the Rhineland, the Ardennes and Central Europe, the 991st placed the first

Oscar Axelson, 1918. *Courtesy of the United States Military Academy.*

American artillery fire into Germany and on Cologne. Its batteries also destroyed many pillboxes in the Siegfried Line by direct fire and participated in street fighting from Aachen to the Elbe. During the Battle of the Bulge, Axelson commanded the 406th Field Artillery Group. On the first day of the battle, at Elsenborn Ridge, he decided on his own authority in the midst of the emergency to use the newly developed, highly-classified proximity fuse that allowed shells to burst in the air above ground troops.

Axelson rose to the rank of colonel and served in the Japan Occupation Government as the chief of the Kochi Civil Affairs team. He retired from the army in 1951 and died in 1979. He is buried at West Point.

The expression "Avant, le Char de Mort" was written in chalk on one of the unit's 155-mm field pieces during the drive from Normandy to Germany in late 1944.

ALL PRESENT AND ACCOUNTED FOR

When war with Spain erupted in the spring of 1898, the U.S. Army numbered fewer than thirty thousand officers and men, scattered across the nation in small units. As a result, scores of combat regiments were formed from what we today call the National Guard. Idaho's first soldier to be killed in action while fighting in a foreign war was Edward McConville, who died with fellow Lewiston resident James Fraser on February 5, 1899, in the Philippines.

Members of Company B, First Idaho Volunteers, form ranks at Second and D Streets on May 3, 1898, in preparation for their service in the Philippines during the Spanish-American War.

5

SKELETONS, SCAMPS AND SCANDALS

*Even the best intentioned of great men need a few scoundrels around them; there
are some things you cannot ask an honest man to do.*
—Jean de la Bruyère

The story of the removal of the territorial seal and government documents
from Lewiston in 1865 has been debated in and out of court ever since
those events transpired. However, that was not the last shadowy event or
character in Lewiston's history. The following are offered as evidence.

CRIME ON THE "MOO-VE"

The word "rustling" evokes images of the Old West, but Lewiston was the
center of a ring of rustlers in 1936. On October 2, prosecuting attorneys
from three Washington counties appealed for aide to stem the tide of
"streamlined" cattle thieves who were striking quickly and quietly with
truck and trailers. "If you fellows think that rustling takes place only in the
movies, you have another guess coming," reported James E. Sareault of
Lincoln County.

Well-organized gangs were picking up loads of animals, interchanging
them to scatter the brands and then marketing them through a packinghouse
hundreds of miles away. S.D. Arnold, Asotin County prosecutor, said that
present laws allowed the rustlers to slip across the interstate bridge into

Lewiston "without being molested" because no proof was available to stop them. Prosecutors proposed more stringent requirements for proof of title to cattle and a more extensive cataloguing of brands.

BOYS WILL BE BOYS?

The Shrine came to Lewiston through the efforts of Wendell P. Hurlbut and James Witt. They were members of the Boise Temple and felt that North Idaho deserved to have its own temple. Officers from the Boise group came to Lewiston in April 1907 and formally initiated thirty-one men, who became the charter members when the temple was instituted on December 6, 1907, the first in North Idaho. The first Illustrious Potentate was Dr. R.V. Kuhn. Members included men from Lewiston, Sandpoint, Lapwai and Priest River. But isn't this a section of the book set aside for scamps?

"Boys will be boys" is an old saying. At least five "nobles" of the Lewiston Calam Temple attended the annual Shrine convention in Los Angeles on June 1, 1925, without their wives. Arm in arm, they were seen parading downtown late into the night and early morning, chanting:

There are no wives with us.
There are no wives with us.
There may be wives with some of the guys,
But there are no wives with us.

MAYBE THEY'LL BELIEVE THIS

The March 12, 1909 *Arizona Gazette* reported that G.E. Kincaid of Lewiston, Idaho, arrived in Yuma after a trip from Green River, Wyoming, down the entire course of the Colorado River, "stopping at his pleasure to investigate the surrounding country."

A month later, the *Phoenix Gazette* printed that Kincaid had made discoveries that "almost conclusively prove" that the people who inhabited a mysterious cavern possibly dated back to Nineteenth Dynasty Egypt. Kincaid claimed he had found mummies and a shrine deep in the cavern in the canyon with

the idol, or image, of the peoples [sic] *god, sitting cross-legged, with a Lotus flower or Lily in each hand. The cast of the face is Oriental, and the carving shows a skillful hand, and the entire is remarkably well preserved, as is everything in this cavern. The idol most resembles Buddha.*

The *Gazette* added that Kincaid claimed to be the first white child born in Idaho and had for thirty years worked for the Smithsonian Institute. The Smithsonian continues to deny any knowledge of him, and, yes, Eliza Spalding was the first white child born in Idaho.

JUST PAY THE BILL

Lewiston resident Alfred McGregor's glib tongue got him into a lot of trouble in Salt Lake City on October 12, 1899. He thought of himself as a successful practical joker but nearly landed in jail for his efforts. A cattleman by trade, McGregor entered a local restaurant and ordered pork chops for breakfast.

"Guess I'm good for a square meal, pard?" he asked.

"Cert," replied the waiter. After devouring his meal in a fashion that was described as "pure Idaho gusto," McGregor headed for the door.

"Forty-five cents, please," said the woman at the cash register. When he protested, the door was locked, and the police were called.

McGregor claimed that he just needed to go to the bank. The policeman who arrived reached a compromise: he and McGregor would adjourn next door to a saloon and borrow some money to pay the breakfast tab. McGregor ordered a beer, blew off the head of foam and plunked down a half dollar in payment. The policeman knew a con artist when he saw one and hauled McGregor off to jail. In no time, he was pleading, "I am a hardworking man…I have a wife and two children, I have."

The court was not amused, "Rather an expensive breakfast," said the judge. "Two dollars or two days." McGregor was subsequently allowed to leave, with an officer, to search for a friend to pay his fine.

SELLING TICKETS ON HIMSELF

Joaquin Miller, circa 1875. *Courtesy of the Library of Congress.*

Cincinnatus Heine Miller was a mixture of bravado and bluster. He tried his hand at many occupations: miner, lawyer, supply courier. Most of all, he fancied himself a poet and took the pen name "Joaquin Miller." The Clearwater gold rush brought him to Idaho and Lewiston, through which he first passed in April 1862. After working in Florence, he took work as a daily express rider between Lewiston and Pierce City.

Judge Israel B. Cowan, who served the Pierce district, often said that Miller was "the biggest liar that ever walked on two legs." Ambrose Bierce called him "the greatest liar this country ever produced. He cannot, or will not, tell the truth." Miller left Idaho for California. Often referred to the "Poet of the Sierras" and the "Byron of the Rockies," he may have been more of a celebrity in England than in the United States.

THE FOREST FOR THE TREES

The sale of public lands in Idaho produced one of the biggest scandals in Lewiston's history. Land was cheap, $2.50 ($60.00 today) an acre. However, something seemed awry to federal officials. Why were so many deeds ending up in the hands of local banker William F. Kettenbach Jr. and his associates? Affidavits surfaced that more than $1 million ($25 million today) in white pine had passed into their ownership. Even President Theodore Roosevelt became involved. After a 1905 review by the Department of the Interior, a special grand jury in Boise indicted Kettenbach, along with fellow residents George Kester,

William Dwyer and Jackson O'Keefe, in the acquisition of ten thousand acres of the best timber land in the state. The indictment charged that the group had paid people to buy the public land and then quickly transfer the titles to them, a violation of the homestead, timber and stone acts, which limited the acreage available to individual buyers. The technique is often referred to as using a "straw man."

On February 26, 1910, the defendants were acquitted in federal court. The government appealed to the circuit court on additional charges and won a judgment on April 4, 1911, against Kettenbach and

William F. Kettenbach Jr., 1899.

Kester for making false reports to the controller of the currency for the Lewiston National Bank. The government dropped other charges on April 11. Kettenbach and Kester were each sentenced to two concurrent five-year terms of imprisonment. And then politics intervened, and the case became more complicated.

In November 1911, President William Howard Taft, who had just visited Lewiston, pardoned Clarence Robnett, who was a star witness against Kettenbach and Kester. Robnett had been convicted of embezzlement from the bank. The embezzlement extended over the previous five years and was made possible by manipulating the adding machines used to compute daily balances. He testified that he had been the intermediary in the land fraud. The uproar over the pardon was immediate. Idaho governor James Hawley issued a scathing public rebuke to the president, asserting that all Idahoans were ashamed of his cowardice in the matter. On November 15, he wrote in an open letter, "No act ever done in connection with the courts of Idaho has so brought into disrepute and weakened the courts in the estimation of our people."

Neither Kettenbach nor Kester served any jail time. Both showed that they had made good all overdrafts and losses amounting to $76,000 ($1.6

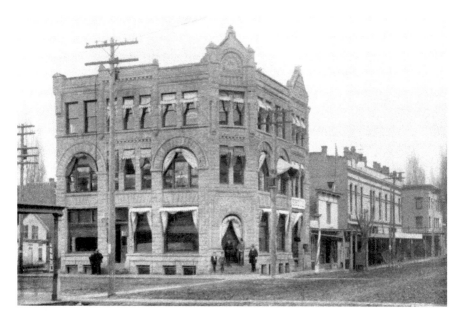

Lewiston National Bank, 1898.

million) in the embezzlement case. Vice-president Thomas Marshall and Senators William Borah (Idaho), John Kern (Indiana) and Harry Lane (Oregon) lobbied President Woodrow Wilson, who issued his own pardon on July 14, 1913. Lewiston and Idaho rejoiced.

Had Kettenbach and Kester fraudulently acquired timber claims? The government hadn't proven its case beyond a reasonable doubt, but the evidence seems clear. To add a little insult, in 1921, the partners sold sixteen thousand acres of "some of the choicest timber in the big Clearwater belt" to the Weyerhauser syndicate for $300,000 ($3.9 million today). Kettenbach retired a very rich man and was largely responsible for the formation of the Lewiston Country Club. The Port of Wilma was named for him and his wife, Mary.

GOOD WORK IF YOU CAN GET IT

Fieldwork by Lewiston students from 2001 to 2004 uncovered an unpleasant and undeniable truth: Lewiston's premier city park still holds many graves. The question became one of "Why could that have happened?"

During the course of the research, at least two independent sources claimed that "they moved more headstones than graves." One source was an editor of the *Lewiston Tribune*, whose uncle had been an official with the original cemetery. In 2002, Lewiston's cemetery staff was certain that a mass grave of unidentified remains was located at the Normal Hill site. Once modern technology was tapped, the resulting answers were discomfiting. Using ground-penetrating radar to look beneath the soil without disturbing it, investigators found no mass grave exists; however, a high percentage of gravestones moved from the old cemetery had no evidence of soil change beneath them. The anecdotes had been proven to be accurate. Who had been entrusted with the task of moving the graves?

The city had signed a contract with Dudley Gilman, a former Lewiston mayor's nephew, on May 23, 1893, "for the removal of the dead from the city cemetery." City Ordinance 144 gave residents until June 15 to remove their loved ones. After that date, Gilman would do the work, and the city would assess charges to offset what the city fathers would be paying him.

Gilman began work no sooner than June 16, 1893. So what was so scandalous? The city paid his contract on July 3, 1893, a mere seventeen days later. And how much did he charge the city coffers—$752.30 ($19,000.00 today, or about $1,200.00 per day). An analysis of his work shows that he probably exhumed no more than 40 bodies out of the 250 that were still most likely in place after earlier exhumations.

In December, Gilman was given permission to plow the site and dismantle the old cemetery fence for his own use or to sell at a profit. When he began to till the site, workmen found out how bad a job he had done the previous summer. Twelve more graves were found. Four of the graves had no remains in them, although the coffins were relatively intact.

So when you visit Pioneer Park, know that you are in a cemetery to this day.

THE PRIVILEGES OF POSITION?

Stories of political insider dealings are nothing new. As river travel became more dependable, land along what would later become Snake River Avenue was becoming increasingly desirable. Steamboats could dock more easily on the Snake River banks than the Clearwater. John Vollmer had his home on the east side of the street.

In 1879, applications for river frontage lots were received by the city council and approved for Dan Favor, Charles C. Bunnell, M.M. Williams, John P. Vollmer, Ed Pearcy and Wesley Mulkey. The bids were accepted and deeds executed upon payment. There was one small problem: Bunnell, Williams and Vollmer were members of the council and had issued deeds to themselves. On May 6, 1879, the new council ordered an investigation into the matter, which had been a clear conflict of interest.

Of note is the fact that the Bunnell home is still found on Snake River Avenue, 125 years after the attempted land grab.

THE POLITICS OF SQUIRRELS

Scandal was once defined by English novelist Horace Smith as "what one half of the world takes pleasure inventing, and the other half in believing." Fortunately for historians, no community is too small to escape a scandal or two, some of which were clearly crimes, some idle rumor, others ignominy. In the spring of 1887, Nez Perce County commissioners found themselves out-maneuvered and embarrassed in a political ploy that is a worthy equal of any twenty-first-century Washington, D.C. stratagem. Reconstructing history is no facile task. Aside from an unavoidable and simple lack of records, subterfuge, contrivance and artifice have always existed in a world dependent on secrecy and covertness. This story is certainly no exception.

The discovery of gold in Oro Fino Creek in September 1860 flooded the region with thousands of treasure seekers who were a civil and criminal law unto themselves. On December 20, 1861, the Washington territorial legislature responded, creating Nez Perce County and appointing two commissioners, a sheriff and an auditor. The county originally encompassed all of the Clearwater drainage south of the river and Lolo Creek eastward to the Bitterroot Mountains. After Congress formed the Idaho Territory in March 1863, Nez Perce County lost the area northwest of Lewiston. In July, Governor William Wallace appointed B.C. Stevens, A.B. Brower and David Reese as the first functioning county commission, which met for the first time in Lewiston on October 5, 1863, to deal with the need for a courthouse and jail. The new courthouse was never built, forcing the county to rent office space. The territorial legislature reorganized the county on February 24, 1864, leaving the northern part of Idaho's current panhandle as an unorganized region but attached to the county in a judicial district. In

January 1882, county commissioners purchased the old Luna House Hotel and refitted it to be the courthouse.

The trail of events in this story began on January 21, 1885, when the Thirteenth Idaho Territorial Legislature passed "an act to encourage the destruction of wild animals in the different counties of the territory." County commissioners were empowered to determine bounties for "varmints." The bill specifically named the "cayote [sic], wild cat, fox, lynx, bear, panther, cougar and lion" as subject to the bounty system, the monies for which were to be paid out of the "Current Expense Fund" of the respective counties. Concurrent with these developments in the legislature, political turmoil characterized Nez Perce County. Residents of Moscow were insisting that travel to the county seat in Lewiston was far too difficult. They even proposed that Moscow could sponsor a second set of county offices. Lewiston would have nothing of the idea, quickly pointing to the fact that Moscow was an unincorporated town, even though the arrival of the Oregon Railroad & Navigation Company's rail line (now Union Pacific) in 1885 touched off a migration boom. Subsequent events would divide the county and its commissioners—Harvey J. Bundy, Charles A. Leeper and John L. Naylor. Bundy and Naylor lived on the Palouse, while Leeper lived in Lewiston.

Interestingly, Latah and Kootenai Counties were first formed in part by an act of the territorial legislature in Lewiston on December 22, 1864. As mentioned above, the two unorganized counties were attached to Nez Perce for all civil and judicial purposes. The act provided that when fifty or more inhabitants desired to complete the county's organization, they should apply by petition to the governor, who was authorized to appoint three "discreet and well qualified citizens of the county as a board of county commissioners" with power to fill offices by appointment until an election could be held.

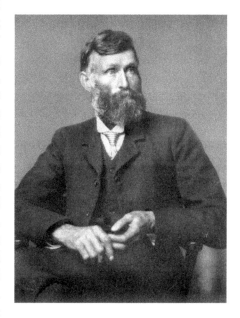

Charles A. Leeper, circa 1900.

Foiled in three attempts to formalize the county and after a spirited media campaign, Moscow residents ambitiously changed their tactics.

In early 1887, the commissioners received a petition signed by the required one-tenth of the "qualified voters" who were taxpayers in the county. The 1880 census had counted 3,965 people. In 1870, when Idaho epitomized the American frontier, the ratio of men to women was four to one. However, by 1890, the ratio was more even: one and a half men to every woman. If one extrapolates a ratio of two to one for the mid-1880s, the population of males in the county would have been around 3,000, a large portion of whom were boys or Chinese, both groups ineligible to vote. While a copy of the petition has never been located, no more than 150 signatures would likely have been required to place the matter before the commissioners. Although the petition document has long been lost to history, conclusions can be easily drawn from the events that followed.

On April 11, the first day of its 1887 spring term, the commission responded with a 4-cent ($1 today) bounty for each squirrel killed in the county. The commissioners invoked section three of the bounty bill to fund the project with an ad valorem levy from the general fund of 50 cents per $100 of "taxable property," or .5 percent. An official "Squirrel Fund" was established. At that rate, and to put it into some perspective, county property currently valued at $150,000 after a homeowner's exemption would generate $750 per year for the fund to control the local *Spermophilus columbianus*, or Columbian ground squirrel. With so much money at stake, a case would have been made to paint the squirrels as dangerous pests.

As the county was developed for agriculture and ranching, humans came into conflict with the squirrels. Columbian ground squirrels eat many of the same foods as free-ranging cattle, so ranchers were acutely aware of the effects these rodents had on their livestock. Public health concerns also arose. Ground squirrels are now known to be hosts for spotted fever ticks and may function as natural repositories for the St. Louis encephalitis virus. Squirrels are a common carrier for the fleas that transmit plague. However, contrary to popular belief, squirrels rarely, if ever, carry rabies and have not been known to cause rabies among humans in the United States. Local squirrel hunters responded with a vengeance, and political events took some strange and coincidental turns.

The county commissioners assembled in Lewiston on Monday, July 11, 1887, for their summer term. On Tuesday, they incorporated Moscow as a result of a petition from a majority of the six hundred residents of Moscow. Spearheading the Moscow group were two local well-heeled

businessmen—William J. McConnell, described in an early history of north Idaho as a "merchant prince," and Willis Sweet. Meanwhile, the commissioners seemed to be having second thoughts about the squirrel fund. On Wednesday, July 13, they requested a legal interpretation from Alfred Quackenbush, the county's district attorney, regarding the powers of the board to enact and maintain the fund. However, there were bills to be paid.

On Friday, July 15, "upwards of $5,000 worth of scalps were presented" for validation and payment. The county clerk noted $4,789.76 in the margin of the second pages of entries. Adjusted for inflation, that amounts to $121,000.00. The largest bill—$1,915.00 ($49,000.00 today)—came from McConnell, McGuire & Company, which submitted nearly 48,000 scalps. Yes, William J. McConnell's company. Following closely in the list of payees were the firms of Durnham and Kaufmann and M.J. Shields & Company, also Moscow companies. The total bills from just those three Moscow groups amounted to $3,445.92 ($86,700.00 today). On close examination, one finds that commissioners Harvey J. Bundy and John L. Naylor submitted bills for payment. The first list of more than fifty individuals and companies contains few names identified with Lewiston. So that answers the question of who signed the petition. On October 15, the commission authorized payment of $60.20 ($1,440.00 today) for an additional 1,500 scalps. The squirrels had certainly paid a price in the political fight.

By the time the commissioners reconvened in January 1888, the tensions between Lewiston and Moscow were the subject of debate in Washington, D.C. In 1887, McConnell and Sweet had persuaded Fred T. Dubois, Idaho's congressional delegate, to introduce a bill to create a new county, circumventing the Idaho territorial legislature and Nez Perce County commissioners. Dubois owed Sweet some favors. Following Dubois's election as delegate to Congress, Sweet was appointed as U.S. attorney for Idaho, although he was not admitted to the bar until the following year, when he was appointed judge of the first judicial district of Idaho and later an associate justice of the Idaho Supreme Court—a fast career track, indeed. It is always good to have friends in high places.

No county had ever been created by Congress, but the commissioners could see the way the wind was blowing. On January 18, 1888, they ordered the "Scalp Fund" to be closed, save for any outstanding and valid claims. The damage had been done. Officials realized from the bills being submitted that very soon those submitting scalps would not live in the county. Of course, the unfortunate squirrels would be nonresidents.

Fred Dubois, circa 1925. *Courtesy of the Library of Congress.*

There was more. Immediately following the minutes entry of the discussion in which the "Scalp Fund" was dissolved, the commission ordered "that from and after this date no bills or charges against the County of Nez Perce will be allowed by the Board of County Commissioners unless the said bill be itemized showing in detail what said charges are for and be duly verified on oath by the claimant." The numbers were not adding up. With an average distribution of 16 squirrels per acre, the death of 120,000 squirrels would equate to the total cleaning of 7,500 acres, or 125 square miles. Some questioned how more than 1,300 squirrels could have been killed every day for ninety days. Some people noted that the squirrel hibernates up to eight months of the year, and colonies near the tree line do not appear until June. Finally, the Columbian ground squirrel is only found in open alpine meadows, dry grasslands and brushy areas. Clearly, something had been questionable about the whole project.

Although no copy of the district attorney's opinion has been found, his findings are not too difficult to retrace. Quackenbush obviously found flaws in the petition. First, squirrels were not mentioned in the 1885 bounty act, and the wording could not be construed to extend to the animals. Second, the petition was based on a bounty bill that did not exist. According to the records of the meeting on April 11, 1887, the petition cited a bill passed in the territorial legislature on January 22 of that year. A search of the official imprimatur of legislation from that session makes reference to House Bill 25 and the destruction of wild animals. However, the volume *Local and Special Laws of the Idaho Territory* from 1887 makes no mention of squirrels, which are not found in the record until 1891. It is not clear

where the idea came from that the petition needed one-tenth of qualified voters' signatures. The 1885 bill never specified any requirement but left the creation of a fund to the discretion of the commissioners. In 1893, the state legislature amended the statute to require one-fourth of "the qualified voters who are taxpayers in the county." Initiatives would need much more popular support. Finally, there seems to have been some question as to the validity of the claimants' affidavits.

All the while, Fred Dubois was working with Senator John H. Mitchell (Oregon) and successfully steering his bill (HR 1648) through Congress. President Grover Cleveland signed the legislation on May 14, 1888—the only time Congress has ever created a county. McConnell and Sweet had finally gotten their way. Both would be elected to Congress, and McConnell would become Idaho's third governor. Sweet successfully arranged for the placement of the University of Idaho in Moscow in return for his opposition to the recent and popular secessionist movement in North Idaho. During the 1870s and 1880s, Nez Perce County was the focus of several attempts to create a new territory combining northern Idaho and eastern Washington. The initiative was finally defeated by an 1887 presidential pocket veto and congressional rejection on February 29, 1888, a move that would pave the way for statehood.

John Naylor would unsurprisingly become one of the first three Latah County commissioners and later sheriff. Harvey Bundy would serve as deputy sheriff for a time but lose the election to head the office. Charles Leeper continued as a Nez Perce County commissioner for many years and ran for the state legislature, only to be defeated after Latah County officials successfully challenged his win at the polls. Lewiston got a measure of revenge in 1896, when Henry Heitfeld defeated Wills Sweet for U.S. senator when the Populists swept Republicans from office statewide.

The creation of Latah County had an immediate effect on Nez

William J. McConnell, circa 1920. *Courtesy of Special Collections & Archives, University of Idaho (99-843-002).*

Perce County. Its population dropped to 2,947 in the 1890 census, a decrease of 28 percent. Lewiston refocused attention on itself and constructed a new courthouse. The opening of the Nez Perce Reservation to homesteaders in November 1895 revitalized the local economy, hard-hit by national financial panics. As the decades passed, Lewiston and Moscow developed along very different cultural paths. By 1900, Nez Perce and Latah Counties were the most populous in Idaho. Lewiston became a mill town in the 1920s, while Moscow's identity was unalterably linked with the university. Thirty miles might as well be three hundred. Who knew the power of squirrels? Such were the realities of Idaho politics in the 1880s.

A NASTY MISSION CLAIM

In the early spring of 2010, David Leroy, Idaho's former lieutenant governor and attorney general, approached several Lewiston historians with news that a University of Idaho anthropology lab archaeologist working from archival National Park Service maps had possibly located the remnants of a stone church at the Spalding Mission that had stood unfinished and crumbling since 1864. The site of the building has been a matter of conjecture for decades. The Nez Perce County Historical Society requested that I investigate the matter and recommend a course of action. The revelations were more than I expected.

Historical mysteries have a way of resurfacing. Some, like James Wilson's early cursive draft of the U.S. Constitution discovered in late 2009 in the archives of the Historical Society of Pennsylvania, are epiphanies elicited by a convergence of accidents. Others lie quite literally buried and require either random erosion or a serendipitous observation to suddenly declare, "Here I am." All three would combine in the case of the fabled and seemingly long-lost structure at the Spalding Mission near Lapwai, Idaho.

Henry and Eliza Spalding responded to the call for missionaries to the NiiMiiPuu (Nez Perce) after four of the tribe's members journeyed to St. Louis in 1831 to find "the book of Heaven and the teachers." Beginning in 1836, and over the next decade, the Spaldings taught the Nez Perce how to farm and plant orchards. They erected a home, meetinghouse, school, mission church, blacksmith shop, sawmill and gristmill, as well as excavated a series of ditches, raised dikes and carved out ponds that provided water to run both mills. Eliza taught school, often with over two hundred students at

a time. The Whitman Massacre on November 29, 1847, convinced the Spaldings to relocate to Oregon's Williamette Valley. By the time of Henry's return in 1862, Eliza was dead, the tranquility at the Nez Perce mission fragile and his life about to cross paths with an unabashed carpetbagger.

The discovery of gold in the Clearwater country in 1860 drew thousands to the region, the majority of which land had been allocated to the Nez Perce in the Treaty of 1855. In May 1861, thousands of opportunists converged on the inauspicious confluence of the Snake and Clearwater Rivers, and Lewiston would soon have a population

Henry H. Spalding, circa 1870.

greater than Seattle, Portland and Olympia combined. The creation of the Idaho Territory on March 3, 1863, precipitated a one-sided renegotiation of the treaty, radically reducing the size of the reservation, placing the mission on its western border and a short ride from Lewiston, the new territorial capital, which would soon have a new chief executive.

Caleb Lyon's political career began in New York, where he served in the state assembly and senate before being elected to the Thirty-third Congress (1853–55). A consummate self-promoter, Lyon cultivated a "Renaissance man" image, successfully convincing people of his talents as a poet, art critic, raconteur and orator, diplomat and politician, not to mention his skills as an engineer. Contemporaries painted him as "a natural born genius" and "one of the oddest figures in Idaho's history." When William H. Wallace, Idaho's first governor, resigned to become the territory's delegate to Congress in late 1863, Abraham Lincoln appointed Lyon as his replacement, although Wallace lobbied the president not to do so. Those who thought Lyon to be an odd choice could not foresee the ramifications. The brief interaction of these two personalities—Spalding and Lyon—provides a context for this story, whose legacy is but a few rough-hewn stones obscured by overgrowth and old highway construction.

Caleb Lyon, circa 1855. *Courtesy of the Library of Congress.*

Successful historical sleuthing requires a certain amount of synergy. No historian assumes he knows what roles seemingly disparate bits of information will play. Working from cellphone photos, a general description, U.S. Senate testimony and directions abstracted from an 1875 deposition, I began my quest for the church by visiting the area to fix the latitude and longitude with GPS, make notations and photograph the reported masonry in more detail. What I found were several large stones of varying sizes, placed with an obvious intent and emerging from rock and gravel fill material some twenty feet below the road level of old Idaho 95, which once carried traffic through what later became the old Spalding State Park. My field notes were peppered with questions requiring research in primary sources to distinguish the find from other anomalies in the area, strewn as it is with other materials. Was the site where I had been led an actual vestige of the old church? And if so, why had its existence become so shrouded, quite aside from the physical debris?

The nexus of the Spalding-Lyon story began to form in August 1864, when newly arrived Governor Lyon attended a church service at the mission. The relationship between Henry Spalding and the new Indian agent, James O'Neil, was not going smoothly. Even fellow missionary Marcus Whitman was calling for Spalding's removal. Lyon came to see for himself, having pledged to inaugurate a "stop thief" policy to stem political corruption in the territory. The old man made an impression on the hard-to-impress Lyon, who later wrote that

through the self-abnegating labors of this good old man, these aborigenies [sic], we feel safe in saying, have benefited more than by all the thousands of outlay by Government. Their savage natures are changed in his presence,

and from the chiefs to the humblest, they obey and respect him as dutiful children a father.

Lyon brushed aside all Spalding naysayers. In a letter from Spalding to his eldest daughter, Eliza, dated August 31, 1864, he wrote that Lyon had authorized a new stone church "on the spot where my old church stood." Spalding had Lyon's backing. "This great revolution in my favor," he would write, "is the work of God...Lincoln has redeemed himself in my estimation." Spalding had been a vocal critic of the president. Buoyed by Lyon's patronage, how could the project fail? Unfortunately, political plums do not grow from seeds. They come from grafting.

My research assistants frequently heard me caution them by saying, "The facts are always less than what really happened." Facts are easy enough to catalogue and relate; you can always fashion a sequence of names and dates, but resurrecting the flesh and blood of the events as they unfolded in real time is quite another matter and requires more perseverance and patience. I had to clear away a lot of literal and historical overburden. And as Sherlock Holmes observed, "When you have eliminated the impossible, whatever remains, however improbable, must be the truth."

Some details are very clear. By late August 1864, work had begun on the church, with forty Nez Perce workers laboring at $1.00 a day (about $14.50 today) to move large native basalt block into place, form the outline of the thirty-six- by fifty-six-foot structure and raise the walls to a height of about seven to eight feet, by some accounts. Total outlays amounted to $5,913.13 ($85,600.00 today) when the latest bill for $1,185.30 ($17,100.00 today) was submitted to Lyon sometime in December. Lyon went duck hunting with two colleagues on December 27 and never returned to Lewiston. The bill was ignored, and work stopped almost immediately, the Nez Perce making "very uncomplimentary remarks of the governor, who employed and promised to pay them."

Lyon's transactions were soon under close scrutiny in U.S. Senate hearings, in which he was repeatedly condemned for policies that belied his "stop thief" gambit. The luster of his charisma had faded in the territory as well. In fact, the *Idaho Statesman* reported that only a "military escort could preserve him from violence, if not from death." He left office in April 1866, discredited and disgusted that he had not gained statehood for Idaho and a seat as a U.S. senator. Lyon withdrew $47,000 ($726,000 today) from the territorial treasury in Boise, saying he was going to deliver it to the federal commissioner of Indian affairs. Lyon arrived empty-handed, claiming that

Spalding mission, circa 1900. *Courtesy of National Archives (Bureau of Indian Affairs).*

the monies had been stolen while he was sleeping on the train between Idaho and Washington, D.C. Of that amount, at least $19,000 ($293,000 today) was owed to the Nez Perce as compensation for their relinquishment of land. Federal officials were not convinced with his defense and moved to recover the money through Lyon's bondsman. In 1874, a jury ordered Lyon to repay bond, and only his death in 1875 saved Lyon from the threat of further prosecution. Historians have long since discredited Lyon's robbery alibi. Meanwhile, the church lay unfinished, an eyesore, an unwanted blemish no one seemed willing or able to expunge.

By the fall of 1865, the structure was in imminent danger of falling down. Walter Gibson testified before Congress that "the freezing and thawing of the mud walls had caused it all to fall out, so daylight is visible in any direction through the walls." It is Gibson's assessment of Lyon's actions that merit the greater value in our investigation:

> *It is not known what authority, if any, the governor had for this expenditure, nor is it known from what appropriation the money expended was taken.*

The Treaty certainly provided for nothing of the kind…The amount thus foolishly squandered should be disallowed in Governor Lyon's accounts, and he or his sureties compelled to refund the money.

Gibson's comments corroborated Spalding's own observations, dated September 1: "I have to say I know not by what authority he commenced the building or by what funds he promised to build it. He did not consult me as to the place or the material." And then Spalding added, "He said he was to build the church to get rid of a 'nasty mission claim.'"

The lure of the paper trail for all that capital outlay between August and December 1864 was more than I could resist. Sometimes, a historian must also be a mathematician. Forty workers being paid $1 a day equates to an outlay of $240 per week, based on a workweek of six days. By the time of the last billing, nearly $6,000 ($87,000 today) had been expended from the territorial treasury. Lyon had already authorized payment for twenty-five weeks of work. The last bill would have covered the previous four to five weeks, most likely those weeks before the Second Territorial Legislature convened and could begin asking for an accounting. Thirty weeks would place a starting date of not later than early May, nearly four months before Spalding wrote of the church and long before Lyon arrived in Lewiston. It is no stretch of the imagination to forge a link between the phrase "a nasty mission claim" and a little old-fashioned doctoring of the territorial accounts. Lyon wanted out of the church project, and by December, he had already decided that his next stop would be Boise, alert as he must have been to the political currents leading up to the opening of the legislature. Lyon was certainly capable of financial skullduggery. One journalist wrote that Lyon was "a conceited, peculiar man, who made many enemies and misappropriated much of the public funds." The Nez Perce had cried, "Show us the money" to a politician deaf to what was due them.

Within a decade, any mention of the building related only to its being used as a convenient southeast boundary marker for descriptions of the mission grounds in a land claim dispute. Its abandonment by the Nez Perce and historians alike would climax in May 1936, when a lavish centennial celebration was held for four days to commemorate the mission's centennial and dedicate a new state park. So obscure was the church's history that the *Lewiston Tribune*'s seventy-eight-page, seven-section insert of Sunday, May 3, in expectation of the festivities, made no reference whatsoever to the Lyon church. Clifford M. Drury, who published his definitive biography of Spalding in 1936 and wrote portions of the aforementioned *Tribune*

issues, included the church only as a brief footnote in his book, in which he says it could "easily be seen." What was left of the $7,100 ($102,000 today) boondoggle proved to be too poor a return on Lyon's "black budget" investments and had been relegated to the status of marginalia. In *All Over Oregon and Washington*, Frances Fuller Victor would comment after seeing the ruins, "Uncle Sam must be a very good-natured relative to permit so many of his nephews to set up expensive monuments to themselves, and to pay themselves handsomely, at the same time for doing it." Yes, the facts seem clear enough; the evidence on the ground is not so explicit.

The traces of the structure are enigmatic. Many historians never have the opportunity to put their hands on the object of their investigations. I could. While acknowledging the dressed and fitted condition of the stones, some observers doubt that the stones are evidence of the church. Knowing that a partial "revealing" of the stonework was warranted, I revisited the site, my basics tools in hand. The earliest comments about the building materials date from Gibson's 1865 testimony, when he referred to "large, rough, basaltic stones laid up in common earth." Removing adjoining refuse and dirt, I laid bare materials of the same description, positioned on a north–south axis and extending more than three meters (ten feet) along the western edge of the highway. Many similar stones are now scattered down the slope to the west. Something was built there, and the only candidate is Lyon's folly. Archaeological "ground-proofing" would supply the definitive answer, which, of course, is not necessary for the solution to be correct. A professionally led excavation is unlikely to happen, given the location of the site, covered as it is to such a depth and only visible along one edge, and the expense of such a venture. Ironically, the efforts of a Lewiston woman may have saved the few stones that can still be seen.

In 1922, the state regent of the Daughters of the American Revolution, Lewiston's Mrs. James (Daisy) Babb, was very opposed to a plan by the Idaho State Highway Department to build the approach road to a new bridge across the Clearwater River by laying the highway through the old mission grounds, and she would stand by her convictions to prove it. Mrs. Babb reportedly drove to the work site and positioned herself in the path of the surveyors, "calmly informing [them] that if they put that bridge across the site they would have to put it over her because she was going to stay right there." The surveyors agreed to relocate the highway fifty feet to the east. Based on the cartographic and written evidence already discussed, the road as originally planned would have completely covered the church

and destroyed several other mission landmarks.

The tale of this territorial misadventure is rich in the relating but lacks the compelling reasons to invest even more funds. Sadly, little would be gained if I had recommended an exposing of the entire site, as the structure was neither completely erected nor lavished with the attention to ensure its longevity. No harm will come if the church continues to tantalize us with but a few well-fitted stones. The eyewitnesses speak with certainty to us, but across too many years, without the chance to explain "what really happened."

Daisy T. Babb, circa 1925.

Lyon's legacy endured a final indignity. By 1909, the old building that had served as the first territorial capitol sat dilapidated and vacant on Third Street. A local civic organization offered to move the structure and restore it as a historical landmark. However, when it learned that the building was the governor's residence, the plan was quickly scuttled. What it failed to appreciate was that the governor's residence and his office were one-in-the-same, and what we call the capitol was an executive office building. Old-timers remembered Lyon too well to restore anything associated with him. The old capitol collapsed in February 1916 under the weight of a record-setting snowfall.

In the end we are left with an edifice of "probable" truth, buttressed by reasonable conjecture: a well-heeled and self-serving scoundrel played false with the trust of provincials. How quaintly modern.

Finders Keepers

The *Hartford (Connecticut) Courant* reported an odd find here on December 12, 1933. Work was progressing in Normal Hill Cemetery to prepare the land for new graves. Some years previously, the cemetery had to perform extensive work to locate graves that had not been properly recorded. So workers were being very careful to note any prior disturbances in the soils. As the laborers were leveling the property, they hit something hard. It turned out to be a fifty-gallon barrel that had been buried in the graveyard. Its contents? Whiskey.

Local anecdotes relate of how local moonshiners used the burial grounds as drop points for their wares. Several grave markers dating from the 1880s are prefabricated, hollow shells to which personalized name plates were attached with bolts. Enterprising distillers would loosen the bolts, swing the name plates to the side and hide the booze inside, retrieving their customers' payments already left there. Interestingly, Prohibition had been repealed on December 5. One can only imagine how upset someone was at not being able to retrieve his stash.

Caveat Emptor

When cash is in short supply, barter. That is what James Kearney and August Bittner did on January 2, 1875. A Lewiston resident since 1862, Bittner needed lumber to build a hotel but lacked the necessary currency. Kearney had the lumber but was willing to bargain. They called in Judge John Clark and formalized a contract. Kearney delivered ten thousand feet of lumber at $20 ($388 today) per one thousand feet. In payment, Bittner delivered milk at $0.50 ($9.70 today) a gallon.

Bittner had rebuilt the Globe Hotel, which had burned in 1868. His fortunes would later turn sour. On January 11, 1881, he was expelled from the Masonic Lodge in the wake of an investigation of proceedings conducted at the Lewiston lodge, which was found to be "farcical, careless, trifling and unworthy of the name of Masonic trials." The lodge was censured for its irregularities. One can only wonder how the milk smelled.

Mr. October Strikes Out

The Kansas City Athletics signed Reggie Jackson for $85,000 ($600,000 today) and sent him to the training camp in Lewiston with the Lewis-Clark Broncs, coached by John McNamara, who would later manage the Boston Red Sox during their disastrous 1986 World Series.

In the May 11, 1987 issue of *Sports Illustrated*, Jackson claimed that he had been the object of racism while in Lewiston.

> *I went to their farm club in Lewiston, Idaho. There I got hit in the head by a pitch in the summer of 1966 and was taken to a local hospital. But they wouldn't admit me because I was black. Our minor league pitching coach, Bill Posedel, called Charlie Finley, and Finley got me out of there. I was in Modesto the next day.*

An investigation by the *Lewiston Tribune* after the article appeared in *Sports Illustrated* uncovered that the emergency room doctor, Dr. William Bond, had examined Jackson and ordered him admitted for observation. The records of the Sisters of Carondelet corroborated the findings, showing that Jackson stayed until July 8. The *Tribune* also demonstrated that records showed the Broncs were billed for the ER visit and hospital stay, with both bills being promptly paid. Jackson had no further comment.

During his stint with the Broncs, Jackson appeared in twelve games, coming to bat forty-eight times, with a batting average of .292, eleven RBIs and ten strikeouts.

The Trouble with Saints

One of the more famous "celebrities" in his day who is virtually unknown to modern audiences was Lee Fairchild, whose reputation rivaled that of Mark Twain more than one hundred years ago. In the late 1880s, his poems, listing his address as "Lewiston, Idaho," began appearing in major newspapers and literary magazines across the nation. Ambrose Bierce frequently ridiculed Fairchild in his columns.

In an 1895 interview for the *San Francisco Call*, Fairchild recounted his days in Lewiston (1886–88), when he was the local Universalist Church minister: "Those were happy days for I did not know any more about the

world than does a member of the Woman's Congress. I had many friends among the old miners." Fairchild eventually left the ministry, reportedly over a misunderstanding about his salary. However, he once said that he "could get along very well with the sinners, but had trouble with the saints." He proved to be the last Universalist pastor to serve Lewiston for many decades. In the 1890s, Fairchild became a popular lecturer and raconteur.

His skills writing and delivering speeches gained notoriety in William McKinley's 1896 presidential campaign. Theodore Roosevelt personally selected him for his New York gubernatorial campaign. He founded the School of Spellbinding, which many of the best political and after-dinner speakers in New York City attended. He served a term as president of the famed Pleiades Club, of which Mark Twain and Stephen Crane were also members. He died in 1910.

SMALL...LIKE A STICK OF DYNAMITE

Hank Vaughn was a very tough little man. Weighing about 125 pounds, he was more than enough trouble for anyone who crossed him. He killed a sheriff at age sixteen. In his book *The River of No Return*, Robert Bailey described Vaughn this way: "Whenever Hank Vaughn came to town, it was noised abroad and all the small boys took their fill of peeking around corners in awe and with bated breath watching to see what new comedy was to be enacted." Vaughn was a bad man when filled with "the cup that cheers."

In one noted incidence at the old Green Front cigar store building, which was being used as a saloon at the time, someone angered him during a card game, and Vaughn called him out to settle the matter with guns. Clasping each other's left hand and pistols in the right, they counted to three, dropped their hands and started shooting. Each man was hit six times, without any lasting harm, although many an opponent walked with a limp the rest of his life.

On another occasion, while on a train journey with his wife, he shot it out with would-be robbers with the aid of his wife, who secretively unholstered his hidden pistols. Vaughn died as a result of a riding accident in 1893.

A Hair-Brained Scheme Gone Awry

Lewiston had never seen anything like it. On June 12, 1929, the Lieutenant Governor William B. Kinne was kidnapped just outside town. A resident of Orofino, Kinne was stopped by four armed men near Arrow Junction. The kidnappers had wrecked their car after blowing a tire. They shot and pistol-whipped two men who stopped at the accident and took their car, taking all three victims to a spot near Greer. Three posses fanned out around the area. Authorities were about to abort their search when two of the culprits were spotted near Juliaetta. It was not long before all of the gang members were caught.

The accused were brought to the jail in Lewiston. When officials arrived with their prisoners, they were met by around 1,500 citizens, many armed with guns, crowded around the front entrance to the new county courthouse on Main Street. While Nez Perce County sheriff Harry Dent created a diversion at the front, Lewiston police chief Eugene Gasser quietly sneaked into the courthouse with the prisoners through the back door. Fearing that the mob might attempt to harm the men, the court held the preliminary hearing in the jail. The men pleaded guilty and were given long sentences.

One of the ringleaders, Edward Fliss, was pardoned in 1934 but did not stay out of trouble for long, taking part in laundering money from the 1935 kidnapping of nine-year-old George H. Weyerhauser.

Radical Home Renovation

Of all the holidays, July 4 is the noisiest, and that noise can mask skullduggery. At 1:15 a.m., a bomb exploded in front of the home of Lewiston's police chief Eugene Gasser, at 814 Eighth Avenue in 1929. The effort to demolish the home was not discovered until dawn, as nearby residents thought the noise came from holiday revelers. The Gassers were awakened but did not investigate. What they found was disturbing. The bomb struck the yard about three feet from the heavy concrete base of the porch. The blast left a hole a foot deep and fourteen inches in diameter. Dirt was thrown across the porch, the superstructure of the porch was shattered and all of the windows in the front of the house were broken. Shrubbery near the explosion was stripped of leaves and branches.

No fragments or fuses were found, leading investigators to surmise that the bomb was constructed from a bottle filled with nitroglycerin thrown from a passing car. Chief Gasser speculated that since the bomb had exploded in the yard and had not been thrown through a window, it suggested that it was either a scare attempt or the bomb fell short of its target. A link to the attempted kidnapping of Lieutenant Governor William B. Kinne just three weeks previously does not seem to have been considered as a motive.

PLAYING BOTH SIDES OF THE BALL

On July 24, 1863, Henry Plummer signed the register at Lewiston's Luna House Hotel. Plummer was the sheriff of Bannock, Idaho Territory, a town later to become part of Montana. In August, he was appointed deputy U.S. marshal for the region of Idaho Territory east of the mountains. He was hanged by vigilantes on January 10, 1864, the last among a large group of "outlaws" executed over the period of a month.

Plummer's reputation is disputed. Some historians contend that he was the leader of a group of nearly one hundred "road agents" known as "The Innocents," who have been implicated in the murders of scores of people. Other researchers feel that he fell out with the vigilante committees with whom he had to work as a sheriff and paid with his life for his defection. In March 1867, the vigilantes received a warning: hang anymore people and the "law abiding citizens" would retaliate "five for one."

AN END-RUN WITH A BARE END

On July 19, 1963, Mrs. Millie Jones, a six-foot blonde arrested on a Texas warrant for armed robbery, called her jailer to her cell at the county jail and told him she wanted to take a shower. She had planned to hit the deputy over the head with a bar of soap wrapped in a shirt. However, jailer Lloyd Stewart opened the cell door right away. She had to carry out her plan then and there, in the altogether, the buff.

"I didn't know what hit me," Stewart reported. "I thought something had fallen off the roof."

She then freed fellow prisoner William Splawn, and the two fled down the fire escape at the courthouse and commandeered a car. The Nez Perce County sheriff's posse captured the pair soon after in a field. Mrs. Jones was fully dressed by that time, having stolen clothing from a farmhouse. When someone said she had gone on the run in her panties, she indignantly denied having anything between her and freedom.

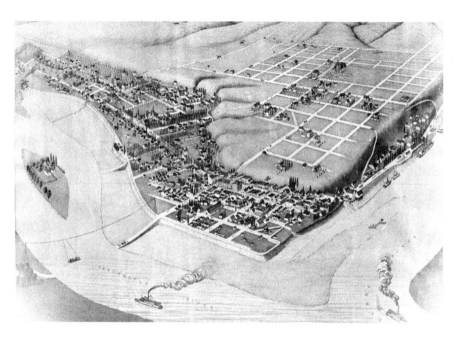

Bird's-eye view of Lewiston, 1898.

6

An Ever-Changing Landscape

They paved paradise
And put up a parking lot
With a pink hotel, a boutique
And a swinging hot spot.
...
Don't it always seem to go
That you don't know what you've got
Till it's gone.
—Joni Mitchell, "Big Yellow Taxi"

As a consequence of the 1855 treaty restrictions with the Nez Perce, Lewiston began as a collection of tents and ramshackle structures. No permanent buildings were allowed. That changed with the one-sided renegotiation of the treaty in 1863. Canvas and wood soon gave way to brick and mortar laid by craftsmen, many of whose creations sadly have suffered from the crowbar and wrecking ball.

A Landmark of a Faded Past

This palatial home was built in 1878 by William Smith, a retired sea captain. He spared no expense, installing an Italian marble fireplace and Spanish mahogany woodwork. A spiral staircase led to the second floor. When Smith

William Kettenbach home, 1941. *Courtesy of Malcom's Brower-Wann Funeral Home.*

departed from Lewiston, the home was purchased by William F. Kettenbach, who died in 1891 and left the home to his son and daughter-in-law, William and Mary Jane. In 1924, Loren Wann purchased the building and converted it into a funeral home. He was later joined in business by Eugene M. Brower. On May 2, 1951, the structure was destroyed by fire. Ironically, the fireplace was saved.

THE SIMPLE DUES OF FELLOWSHIP AND SOCIAL COMFORT

Lewiston's pioneer physicians, including Drs. Madison Kelly and Henry Stainton, established Idaho's first medical community in the city's earliest days. Although a fenced "pest house" was maintained well outside of town to manage contagious diseases and Lewiston had a health officer by 1881, basic nursing and convalescent care remained a family matter conducted at home. In May 1897, the Sisters of the Divine Saviour of St. Mary's Convent proposed a new hospital for Lewiston. The city council conveyed land to

the order in the southwest corner of this park. Neighborhood homeowners objected, fearing a new "pest house."

The project quietly failed, but an 1899 smallpox epidemic that overwhelmed available medical services rekindled the demands for a modern hospital. Under the leadership of Aurelia Bracken, the Sisters of St. Joseph arrived in January 1902 from Illinois and transformed an old seven-room house on Snake River Avenue into north-central Idaho's first true hospital, which was staffed by the nuns and Drs. Charles Schaff, Charles Phillips, John Morris, John Hurlbut and Frank Stirling. In early May, the Boise Diocese granted Father Hubert A. Post permission to pursue construction of a modern hospital on Normal Hill. Working from plans created by Spokane architect Isaac J. Galbraith, local contractors Huber & Frazier raised the four-story, steam-heated brick building for $30,000 ($785,000 today). On February 9, 1903, the diocese took ownership and opened what residents had nicknamed "the Sisters' Hospital." Trained as nurses, twenty-eight nuns cared for the needs of ten to twelve patients every day the first summer in the fifty-bed facility.

In June 1905, the diocese dedicated nearby St. Stanislaus Church, and the order assumed the administrative and teaching duties at the adjacent girls' school founded by the Sisters of the Visitation in 1897. From 1903 to

St. Joseph's Hospital, 1905.

1919, the nuns performed all of the nursing duties at St. Joseph's Hospital. However, when the Spanish influenza pandemic of 1918–19 killed many sisters among the scores who died locally, the hospital inaugurated a professional nursing school to help staff the facility. The addition of sixty beds, new operating rooms and an emergency drive more than doubled the size of the hospital in 1922. In 1925, the order joined the Sisters of St. Joseph of Carondelet. The nursing school closed in 1952.

As times have changed, so too has the response of the hospital in every effort to fulfill its mission to meet with compassion and excellence the healthcare needs of all who seek its services.

A LANDMARK OF A FADED PAST

Arriving from San Francisco in 1873, Raymond and Augustine Saux took over management of the Hotel De France, renting the business for a while. As trade became more prosperous and rents rose too high for them, they bought the lot on the corner of Fifth and E (Main) Streets and erected the Raymond House. On September 5, 1879, the Sauxes opened

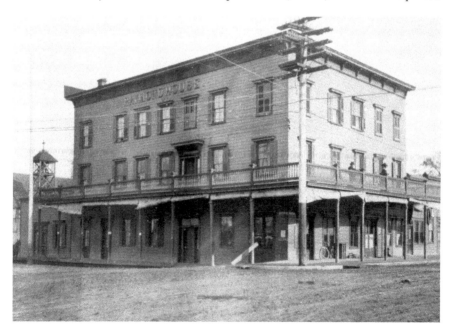

Raymond House, circa 1902.

the new hotel with a grand ball. The Raymond House served as a stage depot for several operators.

William E. Timberlake purchased the hotel from them in 1880 and ran it until 1901, when William Davidson, who had rehabilitated the Hotel De France, assumed management. The old hotel was razed in August 1962 to make way for a parking lot for First Security Bank (now the Center for Arts & History).

A STREET BY ANY OTHER NAME

The advent of Lewiston's request for home delivery by the post office required that the city number every home and business. Another consequence of the plan was that many street names were changed. Here is a list of the most important modifications.

NAME BEFORE 1901	CURRENT NAME
E Street	Main Street and Snake River Avenue (Main Street was for a time also known as Montgomery)
Lewiston and Lapwai Road	Main Street east of the old city limits
Eugene Street	Seventh Street
Swanson Street	Eighth Street
Credley Lane	Ninth Street
School House Lane	Tenth Street
Chambers Street	Eleventh Street
Lapwai Street and Poplar Street	Twelfth Street
Mulkey Lane	Thirteenth Street
Wood Street	Eighteenth Street
G Street behind the Courthouse	F Street
Monroe Street	G Street
Main Street in Thatcher Place	First Avenue on Normal Hill
F Street in Holbrook Tract	Second Avenue on Normal Hill

Street names in the Orchards deserve some comment. Burrell and Powers Avenue were named for Walter Burrell and Harry Powers, who purchased

Main Street (looking west) at the current intersection with Ninth Street, 1898.

several thousand acres and subdivided them into five-acre plots for development. Thain Road was named for Richard S. Thain, the Chicago advertising executive who created and managed the highly successful publicity campaign to bring people to the area above Lewiston.

A LANDMARK OF A FADED PAST

The Hong Shing Laundry, located at Second and D Streets, opened in 1896, becoming the ninth Chinese laundry operating at the time in the city. Born in 1855, Hong had immigrated in 1876 and also owned a Chinese boardinghouse. The next building with a covered sidewalk was the Salvation Army Church when this image was captured, circa 1900–02. The Salvation Army had come to Lewiston in 1896 and would not have a permanent home until 1920.

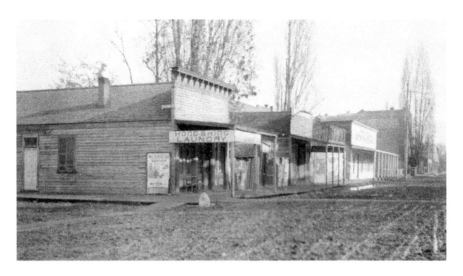

Hong Shing Laundry, Second and D Streets, circa 1902.

A LEGACY OF INHABITED SCULPTURES

The constant moving distractions of daily life often blind us to the solidities in our environment, in and out of, about and around which we move unthinkingly. Famed American designer Phillip Johnson once observed that "all architects want to live beyond their deaths." Few residents of Lewiston know how true that has been for James Homer Nave, whose numerous buildings are icons on the city's skyline and in its oldest neighborhoods.

Born in Fort Wayne, Indiana, on August 15, 1864, Nave lost his mother, Mary Elizabeth (née Gerhart), in October 1879. The 1880 census lists him as "attending school" in Decatur, Illinois, and living with his carpenter-father, Benjamin Franklin Nave, and other family members. The elder Nave died on September 17, 1881, leaving James in the care of his sister Elizabeth and her husband, Richard Casey, who was a worker for the Peoria Decatur & Evansville Railway Co.

On June 8, 1887, Nave married sixteen-year-old Mattie B. DeFever in Fredonia, Kansas. The couple settled for a while in Marionville, Missouri, where their first son, Jesse Homer, was born in 1889. The family was on the move in the next few years. In 1894, they were in Texas, where son Benjamin Floyd was born. By the time of son French's birth in 1896, they had returned to Missouri.

Nave brought his family to Lewiston in 1903 and originally lived in east Lewiston, where the Clearwater Paper Company is now located, near the forebay of the old Washington Water Power dam. The area was once the center of intense agricultural development. He cultivated one and a half acres of grapes, which in one year yielded 1,500 crates of grapes from 1,000 vines and earned him $1,500 ($36,000 today), $1,000 ($24,000 today) an acre. His fame, however, would not rest on the fruitage of plants, as would the legacies of Robert Schleicher and Louis Delsol.

The extent and nature of Nave's training as an architect are unknown. Nothing is mentioned in any account of his life. His career as Lewiston's most prolific early designer began in 1904 with several commissions, the largest of which was the new St. Stanislaus Church on Fifth Avenue near St. Joseph's Hospital. Under the supervision of Father Hubert A. Post, the Gothic-style church was constructed of native stone quarried at Swallow Rock and cost $8,000 ($190,000 today). Two buildings preceded the structure, both built by Father Joseph Mary Cataldo in the downtown area. In 1867, in order to circumvent the ban on permanent structures on tribal land, Father Cataldo procured private property. In 1886, a second church was constructed on Fifth Street between Main and C (now Capital) Streets. Father Post had also run an academy for boys at the St. Aloysius School, which stood next to the old St. Stanislaus Church. The bell at the church came from the building on Fifth Street. The first Mass was recited on June 11, 1905, in ceremonies commemorating Pentecost. Nave's blueprints for the church have been recently rediscovered and made available for study.

On March 27, 1903, the Carnegie Corporation of

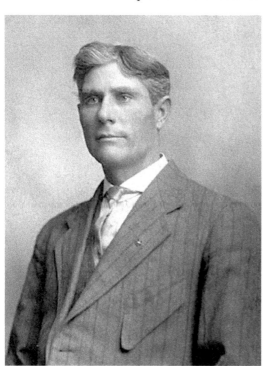

James H. Nave, circa 1905.

New York, responding to an appeal from Mrs. Charles W. Shaff, awarded $10,000 ($250,000 today) to the city to erect a new library. Members of the Tscemincum Club were surprised on April 14, 1905, when hundreds attended the opening of the new building in the Fifth Street Park, keeping the library open until 10:00 p.m. Working from original plans drawn by I.J. Galbraith (Spokane), the company of Frazer & Booth erected the building during 1904–05. In 1903, the city had committed $1,000 ($25,000 today) to ensure construction. In May 1895, the city agreed to donate property for the library "whenever the required conditions were complied with by the [public library] association." The Tscemincum Club had created a city library with a few books and shelves in city hall in May 1900. The new library was capable of holding ten thousand volumes. Nave's 1949 obituary states that he played a role in the design of the building. The extent of that work is unknown, as the original plans were drawn by Isaac J. Galbraith, who was a Lewiston architect in 1903. Possibly, Nave was assisting Galbraith before opening his own office.

Whatever the case, Nave was very busy during this period. He turned his attention to the development of the Blanchard Heights neighborhood now just north of the Lewiston Shopping Center. Initially, all of the homes constructed there were required to cost at least $1,500 ($39,000 today). Nine homes soon populated the area, including those of Patrick and Lydia Hester (1622 Fifteenth Avenue, 1905), James Asposas (1610 Fifteenth Avenue, 1904), William and Elizabeth McLaren (1602 Fifteenth Avenue, 1904), Agnes M. Tamblyn (1506 Seventeenth Avenue, 1905), Frank Booth (1608 Seventeenth Avenue, 1907) and Gaylord Thompson (1824 Seventeenth Avenue, 1904). The dominant style was Colonial Revival, characterized by large, two-story frame houses with bay windows and large porches.

In 1906, Marcus Means, famed Lewiston businessman, approached Nave to design a large brick structure that would become the Means Block, a Romanesque-style edifice that went through various modifications over the years under Means's ownership. The building was the center of Means's wholesale brokerage business in seeds and heavy hardware, along with a restaurant, garage, saloon, assay office and other offices. Noted agronomist Ardie Gustafson experimented with the genetics of peas in a laboratory set up in the basement.

The next year Nave was preparing the plans for "a handsome administration building" for the North Idaho Insane Asylum in Orofino, the design of which showed "a building of stone with granite trimmings, with wide verandas supported by large columns, two stories, attic and basement."

Gaylord Thompson home, circa 1925. *Courtesy of Gary and Cara Snyder/Special Collections, University of Idaho.*

After failing three times (1906 and 1909), the Lewiston School District acted on a successful 1909 levy to build two new schools. Lewiston High School had no gymnasium at the time. Nave designed a combined $43,000 ($1 million) manual arts–gymnasium building that originally occupied the

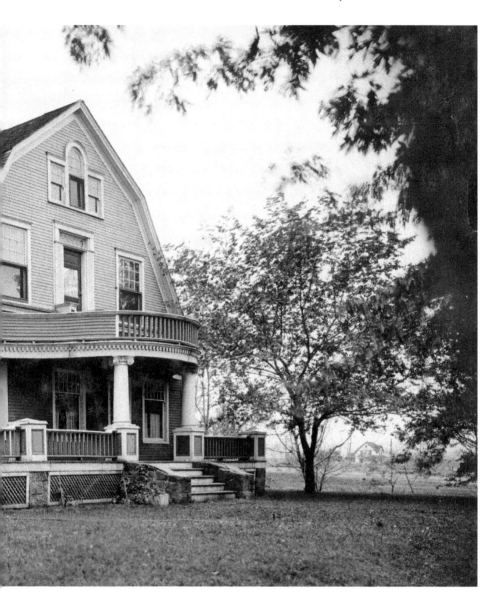

1200 block of Ninth Avenue. In 1914, the building was expanded to house the upper grades. With the opening of the new school, the district became one of the first in the nation to change its grade distribution to a 6-3-3 plan, which it maintains to this day. Garfield School was constructed for $12,000 ($290,000 today) from Nave's "colonial revival" design on Fifth Avenue between Twenty-ninth and Thirtieth Streets, with large hallways, stairwells and the sash windows that were popular during the period.

Nave's contractual work began to extend beyond Lewiston in 1909, when he designed the Presbyterian Church in Lapwai (Idaho), followed by the Bank of Juliaetta (Idaho) in 1910. His design was accepted in 1909 for the Grangeville, Idaho J.C.Penny store, which is a local landmark that retains its tin ceilings. He also designed most of the school buildings on the Camas Prairie.

In 1910, one could find his services advertised among the "professional men" of Lewiston, with offices in the Salsberg Building and a telephone number of Red 551-1572. In July, he joined fellow Lewiston residents in the purchase of properties near Williams Lake in northern British Columbia. Merchant Theron S. Ward, pharmacist Arthur E. Carlson and Nave requested permission to purchase the property in the Cariboo Land District, with his property measuring one square mile. It would seem that the three were engaging in a little land speculation, with timber and mineral rights surely on their minds. Ward was also an officer of the new Lewiston Bank of Commerce, as was James Asposas.

The local Baptist congregation contracted Nave's services in 1911 to design its new church on the southwest corner of Eighth Avenue and Eighth Street. His plans were used to erect the Lewiston Motor Company.

While James was busy creating a good portion of Lewiston's skyline, Mattie became deeply involved in Lewiston society and civil affairs. She joined the Tsceminicum Club and served a term as president. She was a charter member of the Alice Whitman Chapter of the Daughters of the American Revolution. During World War I, she served as the chairman of all five Liberty Loan drives and helped found the American War Mothers.

Nave and Dr. John Baker Morris, one of Lewiston's foremost civic leaders for several decades, were close friends. The Morrises were among the Lewiston guests at the Payette, Idaho wedding of the Naves' son Floyd in May 1919. A few years earlier, Morris commissioned Nave to design a new building—the Morris Block for the corner of New Sixth and Main Streets. The partnership culminated in a 33,600-square-foot structure with two floors and a full basement for storage. The building housed the Eagles Lodge for many years.

In 1914, Nave set about designing and constructing a building for himself, a Swiss chalet–style apartment building on Eighth Street near the Methodist Church still familiar to most residents of Lewiston. He and Mattie moved in and lived there together until her death on April 19, 1931, after a long illness. The apartments had become his professional address by the fall of 1914, and it was there that the couple bore the loss of their first son, Jesse, who died in September 1918.

Nave Apartments, 1914. *Courtesy of Mike Mitchell.*

Nave's largest project was a commission from C.J. Breier (1869–1958), chairman of a vast chain of regional retail stores. Breier came to Lewiston in 1904 from Helena, Montana, and opened his first store, the Hub. In 1921, Nave designed a five-story, Chicago-style building for the corner of Seventh and Main Streets to serve as the chain's headquarters. The 65-by 120-foot structure cost more than $150,000 ($2 million today) to build and contained 102 rooms on the upper four floors that were rented as offices and served by an elevator that was for many years one of the most adventuresome rides in Lewiston. Several of the rooms were designed as suites. The ground floor and the full basement were used to house the new C.J. Breier Store, successor to the Hub. When the building opened on November 25, 1923, it was festooned with lights, two orchestras played and the Rusty Hinge Quartet serenaded visitors on every floor. Maxine Breier, C.J.'s daughter-in-law, remembered that "he was caught by surprise by the crash of 1929, and he couldn't withdraw his funds before his bank experienced a run. He eventually lost the stores, but kept the home building [Lewiston's store]."

For all his accomplishments, Nave's career did suffer one noteworthy setback. In early 1908, Frank B. McGrane, who was leasing the Bollinger Hotel and owned several adjacent lots, was anticipating erecting an addition to the hotel, ironically next to the Means Building. Nave learned of the

plans and approached McGrane for the job. Sketches were prepared, but the project was temporarily abandoned. McGrane later revised his plans, but for an even larger structure, only to abandon that idea as well. Nave sent him a bill for $240 ($6,000 today), later renegotiating the bill to $120 ($3,000 today). In December 1908, McGrane finally decided to go ahead with plans to erect a larger and more substantial building than originally intended. Nave sweetened the deal by offering to apply $60 ($1,500 today) of the previous bill to a new contract. The new building was to consist of one story with a basement, although the structure had to be capable of carrying three additional floors. That's where the disagreements started.

McGrane was not a satisfied customer. When he became doubtful of Nave's plans and asked him to strengthen the building by putting in iron pillars to take weight off the partitions, Nave became angry and refused to make any changes. McGrane retained the services of Spokane architects and received entirely new blueprints for the building. He took Nave to court to recover the costs of the plans, contending that the drawings would not produce a suitable building. Nave sued for costs based on a purported agreement for 3 percent of the cost of the building. A local jury sided with Nave. McGrane appealed to the Idaho Supreme Court, which overturned the decision, stating, "Clearly, according to the authorities on architecture, engineering contracts and specifications, said plans and specifications were not sufficient for the purpose for which they were intended." Nave was assessed the court costs.

After the completion of the Breier and Morris buildings, Nave's work as an architect ebbed. By the late summer of 1926, his professional card no longer appeared in the *Tribune*. He moved to Clarkston in 1933 and operated a sand and gravel pit. This new venture was coupled with mining interests in the Ten Mile District, near Golden, Idaho.

His last years were spent quietly. Nave died on October 5, 1949, at the age of eighty-five from heart disease and the lingering effects of pneumonia.

Although his career in Lewiston did not span as many years as other regional architects, his legacy can be no better expressed than in the list of twelve structures on the National Register of Historic Places to which his skills as a structural designer are attributed. By the 1950s, his mantle would be assumed by Hugh Richardson, but that is another story.

Weisgerber Building, circa 1906.

A LANDMARK OF A FADED PAST

One of Lewiston's first major downtown structures, the Weisgerber Building was officially handed over on February 28, 1905, to owner Christ Weisgerber and tenants who had been queuing up for occupancy since November 1904.

Built at a cost of $65,000 ($1.6 million today), the structure contained 450,000 bricks, a Vermont marble entrance on Fifth Street, oak stairways, forty-six offices and apartments, steam heat, electric and gas lighting and telephone service. A fire of unknown origin destroyed the building on March 1, 1994.

A CONFLUENCE OF RIVERS AND STEAM

Piloted by Ephraim W. Baughman, the *Colonel Wright* was the first sternwheeler to ascend the Snake River to its junction with the Clearwater. After the strong current snapped the boat's tow line at Big Eddy (present-day Lenore), the Oregon Steam Navigation Company (OSN) selected a more suitable site for the supply community to the Nez Perce mines, and Lewiston was founded on May 13, 1861. Baughman would command all of the steamers on the

Snake at one time or another, and the OSN monopolized river commerce for more than twenty years. By 1885, railroad bridges crossed the Snake River miles downstream from Lewiston. Although the structures were swing spans allowing the boats to past, many veteran pilots felt that the coming of the railroads would doom river trade.

However, shipping wheat to the Portland markets by rail proved too unreliable. In 1879 alone, steamboats carried nearly sixty-six thousand tons of grain downstream. Every boat could be heavily laden with sacks of wheat, and travelers to Lewiston preferred the comforts of the sternwheelers to smoky, noisy railroad carriages. The larger boats contained a dozen or more staterooms and could accommodate 250 passengers. During height of the sternwheeler era, three boats arrived in Lewiston each week. Steamboat travel was not without dangers. The *Annie Faxon* was a familiar sight for fifteen years, working the Snake River between Lewiston and Riparia (downriver from Little Goose Dam). Tragedy struck on August 14, 1893. As Captain Harry C. Baughman, Ephraim's son, turned the boat toward shore to make an unscheduled stop, a massive explosion tore away the top decks, killing eight.

On July 12, 1922, the *Lewiston* and the *Spokane* were moored together in the wharf area that stretched along Snake River Avenue. The night watchman noticed a yellow flame coming from the *Lewiston*'s galley and called for help. Lewiston and Clarkston firefighters arrived within minutes but could do little

Riverboats *Lewiston* and *Spokane*, July 13, 1922.

other than keep the flames from spreading ashore. The last sternwheeler left the city on February 29, 1940, when the rebuilt *Lewiston* cast off, bound for Portland. Disaster was narrowly averted after the new interstate bridge span would not open, and the *Lewiston* lost power and had to be beached downstream. Landlocked for decades, Lewiston became a seaport for the second time in its history in June 1975, after the completion of the Snake River dams.

CEMETERIES ON THE FRONTIER

For nearly thirty years prior to statehood, Pioneer Park served as Lewiston's cemetery. While the exact number of burials is unknown, records indicate that more than four hundred graves could be found there by 1889. The earliest burial was not recorded, nor has any plat map surfaced. However, at least one source states that in 1864 the fragmentary remains of Lloyd Magruder "were decently buried in the cemetery in Lewiston." The earliest burial associated with an extant headstone was that for Rebecca Newell in 1867. The official city survey allocated eight acres as burial grounds, and the area is still known as the "Cemetery Addition."

Church records show that three distinct graveyards shared the park: City, Masonic and Jewish. The Masonic plots were located where the old Carnegie Building now stands. As late as 1950, workmen were taking care during excavations not to carelessly disturb possible grave sites. The City section was found in the area where the playground is now located. The Jewish cemetery is thought to have been located to the east, across the park road.

In 1879, the city council called for bids to build "a good substantial picket fence," five feet high, with posts of good cedar at least five inches in diameter. Councilors instructed that the fence had to be white-washed. However, plagued by a lack of water and no cemetery fund to cover the expenses of proper upkeep, the graveyards soon became eyesores and the subject of frequent public complaints: "Gates in bad repair…Cattle frequently get in and destroy and knock down graves and the tombstones."

In December 1888, the city council forbade any further interments within the city limits and permanently closed the old cemeteries. Workmen began exhuming bodies in the Masonic graveyard in March 1889 and transferred the remains for reburial in the then new Normal Hill Cemetery. Exhumations continued until 1895, but the lack of proper record keeping

and a sparseness of grave markers prior to 1880 seriously hampered the work. Many headstones were moved without disturbing the bodies beneath them, and a large percentage of old graves were unmarked.

The Chinese did not arrive in Idaho with the first influx of treasure-seekers in 1860. However, thousands began appearing in the gold fields across the territory. The legislature enacted laws forbidding marriages between Chinese and non-Chinese and prohibited the Chinese from working in the claims without the payment of a monthly tax. At any given time from 1863 to 1890, Lewiston was home to 100 to 125 Chinese. When the city's census declined after the gold rush, they remained and became a large minority community, numbering 10 to 15 percent of the population.

Cultural differences between the Chinese and non-Chinese communities precluded the burial of Chinese bodies in the Fifth Street Cemetery (now Pioneer Park). By the mid-1860s, the search was underway for a suitable site.

A Chinese cemetery differed in many ways. According to the principles of feng shui, a south-facing slope was preferred, as it was believed to be rich with "qi," a vital energy thought to flow through sites, while slow-moving water around the burial ground was believed to bring good luck. To achieve harmony with its surroundings, a proper location needed to be protected from evil winds and exposed to good winds. The ideal place would resemble

Ah Moon and Ah Loy, among the last surviving early Chinese miners, circa 1932.

a tiger, horse or dragon (symbols of good luck). Graves were oriented north to south.

Chinese elders found a place meeting their needs in the far southwest corner of the original city, an area later connected to town by Prospect Avenue. The first documented death of a Chinese resident occurred in 1870. At least three of the Chinese miners murdered at Deep Creek in May 1887 were buried there. The graves would have been purposefully shallow. In China, reburials were anticipated. Until the late 1930s, most Chinese who died in the Pacific Northwest were exhumed and sent back to China for reburial with their ancestors. Those who knew their burial might be in foreign soils subscribed to services to have their skeletons repatriated.

Chinese burial practitioners scraped away any remaining flesh, washed the bones and packed them in metal boxes for shipment. The greatest percentage of exhumations and reburials were reserved for men. Women, married and unmarried, and children were most often excluded. As a result, visitors should never assume that former Chinese cemeteries are empty of remains.

When the Lewiston City Council forbade any further burials within the city limits, leaders of the Chinese community signed a ninety-nine-year lease with the city in May 1891 for a dedicated section of Normal Hill Cemetery. After many years of neglect, attempts to sell the old cemetery and even its use for victory gardens, the city reaffirmed a commitment to maintain it as a peaceful place.

A Landmark of a Faded Past

Before its use as the Palace Restaurant, this building was a general store and a furniture and hardware business. The Lewiston Steam Laundry took ownership by 1903. In 1907, the structure was mostly destroyed when burglars used dynamite to open the company's safe and "the front of the building was practically blown out." The building was torn down and the lot sat empty until the offices of the Pacific Telephone & Telegraph Co. were built in the 1920s. That structure, the Bell Building, is now owned by the city.

Palace Restaurant, Third and D Streets, circa 1902.

BATTLING THE HAUGHTY DREAM ON FLAME

A GOOD MOVE—The Citizens of Lewiston have organized an efficient Hook and Ladder company, numbering about 70 men.
North Idaho Radiator, *January 28, 1865*

Lewiston's first major fire destroyed nine buildings on February 2, 1868, including the Globe Hotel, Norton & Bunker's Challenge Saloon and the California Bakery. In the 1870s and 1880s, the city began regulating stoves, furnaces and fireplaces, set limits on the types of buildings that could be erected and supplied volunteer crews with newer equipment. Lewiston's capacity and commitment to fight large blazes came into question when the city's Chinatown erupted in a multistructure fire on November 19, 1883. Some local residents urged volunteer firefighters to delay their efforts. By the time they did act, the fire had grown into a conflagration that consumed Lott Wiggin's blacksmith shop, the Chinese temple and the homes of fourteen families. The city installed a half-ton fire bell in April 1884. Volunteers would rush to fight a fire, alerted to its location by a prearranged code. The bell was moved to Pioneer Park in 1907, where it remained in use until 1928.

In the fall of 1890, a fire at a local lumber yard demonstrated the need for a better organized department. The mill and surrounding buildings were saved, not through the efforts of the fire department, but by residents equipped with buckets of all descriptions. Fire hydrants were installed

Lewiston fire bell,
circa 1915.

throughout the town in 1891, and on August 3, the city council passed Ordinance 120, formally creating the Lewiston Fire Department. Charles F. Leland was the first person with the title "chief of the fire department," an unpaid position until 1903.

On August 8, 1897, a major fire broke out in the evening. A lantern exploded in the hay storage area of the W.J. Collins livery barn and quickly consumed it. The entire block that now contained the Nez Perce County Historical Museum was destroyed, including the homes of Noyes Holbrook and John Barbour. Lacking insurance, Collins lost $4,000 ($102,000 today) and Holbrook $2,000 ($51,000 today). Firemen were late in arriving, as the fire bell had rung out a wrong code, and only the accessibility of water from the Clearwater River kept the blaze from burning the entire west end of town.

By 1900, the city was using a horse-drawn "chemical engine," in which a mixture of water and sodium bicarbonate reacted with sulfuric acid to expel water at high pressure. In 1909, the department purchased its first motorized fire engine, an air-cooled, four-cylinder "combined hose and chemical truck." Until 1915, firemen also served as policemen.

Fires continued to remake the city's skyline, but the inferno that raged on the night of December 5–6, 1917, is one of the most memorable. A small fire broke out in the basement of the east wing of Lewiston State Normal School (now Lewis-Clark State College). The alarms went out, but by the time crews arrived, the wing was fully engulfed in flame. Two fireman narrowly escaped death when the middle portion of the north wall collapsed shortly after midnight. Firefighters saved the central portion of the building and its new west wing, but the school's library and records were a near total loss. Fire losses in the city between

Lewiston State Normal School, December 6, 1917. *Courtesy of Lewis-Clark State College.*

1925 and 1937 were twice the national average and led to a complete reorganization of the department in 1938.

> *But sound aloud the praises, and give the victor-crown*
> *To our noble-hearted Firemen, who fear not danger's frown.*
> —*Frederic G.W. Fenn, "Ode to Our Firemen," 1878.*

A LANDMARK OF A FADED PAST

The John and Sarah Vollmer home at the top of the Fifth Street Grade was Lewiston's grandest. After living on Snake River Avenue since 1871, the Vollmers took ownership of their newly constructed home in 1900. Mrs. Vollmer took a very hands-on approach to its design and the materials used. In 1955, decades after their deaths, the old mansion was being razed. Workers discovered a false wall in the spacious kitchen.

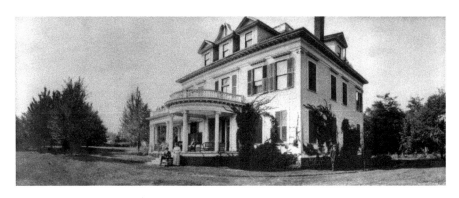

Vollmer home, circa 1910.

Behind the wall was a secret "bank" Vollmer had maintained at home, and inside that sanctorum was a stash of uncirculated gold coins worth a small fortune.

WHO WOULD HAVE THUNK IT?

*If you do not expect the unexpected you will not find it, for it is not to be reached
by search or trail.*
—Heraclitus

For one reason or another, there is no end to Lewiston tales that defy
classification. After all, the city is more than 150 years old and has been
home to some pretty "interesting" people. Here is a collection of whimsical
stories that have one thing in common: they are all tied to Lewiston.

RECYCLE A POUND, SAVE TONS

Did you know that Lewiston was the first city in the United States to
voluntarily launch a community drive to save scrap aluminum? On June 20,
1941, Lewiston began preparations for the "national emergency" that would
drag the United States into World War II within a few months. A small
mountain of items was collected during the six-day campaign and stacked in
a special stockade erected on Main Street in the heart of the business district
near the Breier Building.

Betty Van Ditto, a member of the 1941 class of Lewiston High School,
was selected as "Miss Aluminum of the Pacific Northwest" by the chamber
of commerce. City policemen were assigned to guard the materials, which
included donations from residents outside the city as far away as Grangeville,

Idaho. The first donation was an aluminum sales tax token from Colorado. Local Boy Scouts canvassed every house in town for materials. A total of 1,493 pounds of aluminum was gathered.

Funds generated from the collecting of pots and pans were donated to the United Service Organizations (USO), which had been formed on February 4, 1941. The wholesale price of aluminum was 17.5 cents a pound in the summer of 1941. The USO received $253.81 ($3,900.00 today). Betty's outfit was something to behold.

A CONVERGENCE OF COINCIDENCE

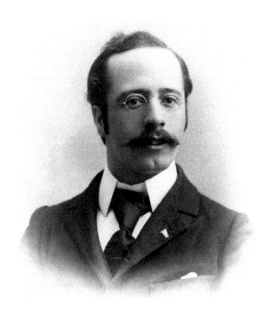

Walter Parr, circa 1900. *Courtesy of Beloit College. Beloit, Wisconsin.*

In a bit of odd coincidence, Reverend Walter Robinson Parr has two links to Lewiston. A graduate of Beloit College (Wisconsin) in 1895, Parr was an English-born preacher and author. After completion of studies at the Chicago Theological Seminary, he served congregations in Illinois, Indiana and Washington before becoming minister for Lewiston's Pilgrim Church and Orchard Church in 1921. The Pilgrim Church building still stands on the corner of Tenth Street and Tenth Avenue.

During the time that he was pastor of St. Paul's Congregational Church in Chicago, he befriended Elias Disney, who named his fourth son after the pastor. You know, Walt Disney. Parr died in Lewiston on March 25, 1922, of influenza and pneumonia, leaving behind his wife and seven children.

And by a twist of circumstance, Walt Disney would marry Lillian Bounds in July 1925 at 918 Third Street, just a few blocks from where Parr was buried.

Junk Mail with a Life of Its Own

Lewiston's postmaster Mrs. Letitia Erb had a problem on June 3, 1948. A dilapidated and wriggling package was brought into the old post office on F Street (now city hall) by two excited children who found the package in the street. They figured that it belonged to the post office, since the package had a February postmark and part of a Lewiston address. Mrs. Erb was not all that pleased.

The packaged contained a skunk, and the animal soon made his presence known in the lobby of the post office. The children were thanked for their kindness, but Mrs. Erb declined custody of the package.

"Oh, goody," chuckled ten-year-old Joe Burke. "If no one owns him, if he doesn't smell any worse, if mama will let us…we'll raise him as a pet." No word on his mother's reaction.

A Landmark of a Faded Past

The Cash Hardware Company once owned much of the 400 block of D Street, now taken up by the new Lewiston City Library, which renovated the company's main building dating from the 1890s. The *Lewiston Tribune*

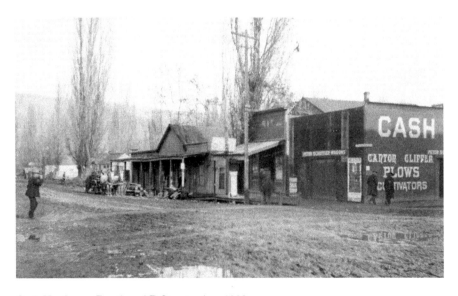

Cash Hardware, Fourth and D Streets, circa 1902.

had offices on the second floor of that structure for several years before moving to a site on Fourth Street south of D. The second building shown on the street was a restaurant and the third once one of Lewiston's ubiquitous saloons.

IN BED WITH THE DEVIL

Meredith Willson's "The Music Man" carries the famous line: "Trouble right here in river city." Ordinance 234 was passed by the city council on September 5, 1898, to license any businesses operating "a nickel in the slot machine." The law prohibited the paying out of money from these machines without a license. That doesn't sound like much of a story, but the city grew to depend on the licensing and taxation of slot machines, which could be found all over town, including in the buildings used by the Elks Lodge, Eagles and Veterans of Foreign Wars. The machines took nickels, dimes and quarters. Elimination of the devices became a contentious issue in city politics. The Elks Lodge was even annexed by the city to conform with a 1947 law on local option taxes. In November 1949, a record number of voters soundly defeated a measure to ban the slots and raise taxes to fill the void. By 1951, the city's coffers received $340,000 ($3 million today) a year from slot machines fees.

Masses of voters went to the polls on November 14, 1951, in a special referendum over whether Lewiston would continue to use slot machines and punchboards to raise revenues for the city's operations. The vote was overwhelming against the issue, with only the precinct in north Lewiston voting in favor. The city council had referred that matter to the voters because of the controversial nature of the matter, which evoked strong emotions on both sides. Business leaders favored retaining the gambling devices. The local ministerial association was vocally opposed. Reverend Douglas Vance, pastor of the Congregational-Presbyterian Church and president of the association, received threatening phone calls and was given police protection. Opponents argued that the money the city would lose would have to be made up in higher taxes. The vote was not all that close: 2,359 to 1,567 to ban the slots, which were gone by January 1, 1952.

The state legislature finally acted in 1953, and slot machines were banned in Idaho on January 1, 1954. By 1957, Lewiston had to appeal to the legislature for permission to raise its levy ceiling. All of the slot machine surplus monies had run out.

THE HONOR OF A CHILD'S ADMIRATION

Born and raised in Lewiston, Second Lieutenant William W. Caldwell was an army air corps reserve pilot with the Ninety-fifth Pursuit Squadron. In October 1930, he was escorting a courier plane transporting Japan's Ratification Document for the London Naval Treaty from Victoria, British Columbia, to New York City. On October 15, he crashed his Consolidated Fleetster while trying to land in a blizzard seventy miles northwest of Cheyenne, Wyoming.

A sixth-grade Japanese boy, Shigeyoshi Fukushima, was so moved by the reports of Caldwell's death that he diverted seventy yen (nearly $950 today) from his vacation money and donated the funds to the U.S. embassy to buy flowers for Caldwell's grave in the San Francisco National Cemetery. A Tokyo newspaper picked up the story, spurring others to contribute. A bronze plaque was dedicated to Caldwell in 1931 at the cemetery. Shigeyoshi was quoted as saying: "I have never thought my small contribution should have caused a great sensation among Americans throughout the United States. I feel very shy and bashful."

Caldwell was awarded the Distinguished Flying Cross.

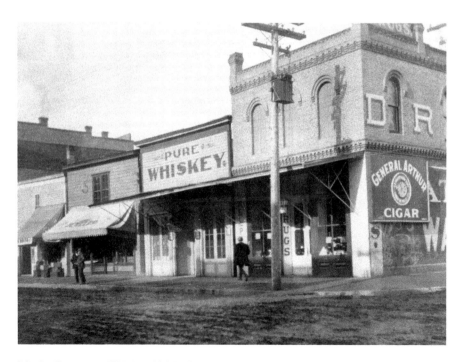

Moxley Drugstore, Third and Main Streets, circa 1902.

A landmark of a Faded Past

Dr. John Quincy Moxley purchased Dr. Madison A. Kelly's "pioneer drug store of the town" in 1874. Dr. Kelly was Lewiston first official mayor (January 1863). A 1928 issue of the *Lewiston Tribune* related the recollections of Mary A. Porter, who came to Lewiston in 1884. She matter-of-factly told the reporter that she "saw the bodies of six cattle thieves hanging over the middle of Main Street, in front of Dr. Moxley's drug store." These buildings were razed by 1905 to make way for the Fix, Moxley and Squier buildings, large storefront and office structures that fell victim to the wrecking ball in 1982 despite years of community efforts to stop their destruction.

Best to Test the Water, Chuck

"Professor" Charles Harmon dove 110 feet from the old interstate bridge on October 15, 1902, in front of two to three hundred witnesses. Harmon's dive was reported to have been "neatly executed," with him "turning in a sweeping curve in the air." The feat was not without sacrifice. When he hit the water, spectators noticed that he did not disappear beneath the water, although he made quite a splash. Harmon broke his ankle on the rocks at the bottom of the river, which, upon examination, was found to be just seven feet deep.

Harmon repeated the feat on January 2, 1903, this time from a height of seventy-three feet and with nearly three thousand people watching. Why Harmon would have chosen October and January is anyone's guess. Locals knew that these were periods of low water in the days before the dams on the Snake River. Maybe the spectators were laying some bets on whether the fool would really try it.

No Good Deed Gone Unpunished

The *Pittsburgh Press* of January 23, 1906, related an interesting story about U.S. senator Fred Dubois. When Dubois was a young man, he worked for his father near Lewiston as a range "captain," assigned to check with cowboys who were riding the herds. One morning, as he was readying

himself and his horse for the day's ride, his mount reared and bucked, startled by something.

Not far from town, at a location occasionally used by vigilantes for summary justice, his horse spooked again. Dubois saw what he thought to be a ghost but soon determined to be a naked man, who ran upon seeing Dubois. He reached the man and dismounted to capture him, but he had to return to his horse, which was pulling away in fear. He placed a blanket over its head and lassoed the naked man. Tying the "ghost" across his saddle, Dubois headed back into Lewiston.

No sooner had he reached the outskirts of town than he was met by the sheriff, who came running with a small group of residents, who now slunk away in an unconcealed panic. Dubois had captured not a ghost but a runaway smallpox patient, who died soon after his return to town. The man's caregiver also died. Dubois lost all of his clothes and his blanket but lived to serve on the U.S. Senate and tell a good story.

YEAH, YEAH, YEAH

What link could there be between the Beatles and Lewiston, Idaho? The answer is Ken Mansfield, a Grammy Award–winning record producer, former U.S. manager of Apple Records, a high-ranking executive for several record labels, songwriter and author.

Born in 1937, he graduated from Lewiston High School in 1955. During his college days in San Diego, he sang with a local group and became associated with Capitol Records, rising quickly in the organization at the time when the Beatles were entering the American market. In addition to the Beatles, while at Capitol, he was also responsible for overseeing the recording careers of the Beach Boys, Glen Campbell, Bobbie Gentry, Lou Rawls, Buck Owens and the Steve Miller Band.

In 1967, Mansfield became the U.S. manager of Apple Records and was one of the few people in attendance at the group's famous rooftop concert on January 30, 1969, the last time the Beatles performed in public as a group. The documentary of the performance, *Let It Be*, won an Academy Award in 1970. After working for CBS/Barnaby Records, he started his own production company and produced the Outlaws group of Waylon Jennings, Willie Nelson, Jessi Colter and Tompall Glaser. Mansfield is now an active minister.

Ken Mansfield and Paul McCartney at the Century Plaza Hotel in Los Angeles during the festivities surrounding the launch of Apple Records, 1968. *Courtesy of Ken Mansfield.*

PASSPORT, PLEASE

At midnight on July 2, 1950, Lewiston repealed daylight saving time. A little explanation is necessary. In 1942, the United States went on war time, which was discontinued in September 1945. From 1945 to 1966, the federal government did not mandate daylight saving time. The lack of a national policy created a mess, with local governments, like Lewiston,

able to opt in or out of the program. In April 1950, the city council asked for the community's input and then voted to go on daylight saving time. The repercussions were immediate.

Even a relatively short trip from Lewiston meant you had to change your clock back and forth. It would be 11:00 a.m. in Lewiston and 10:00 a.m. in Clarkston and the Orchards. In the mid-1960s, the airlines successfully lobbied Congress to create a uniform program. The Uniform Time Act became effective on April 13, 1966, and Lewiston was back on daylight saving time.

LOOK TO THE SKIES

On July 5, 1947, a radio announcement that discs were flying over Lewiston sent hundreds into their yards for a look. Weatherman Louis Krezak said the objects were moving eastward with the prevailing wind and were probably a cloud of weed seeds. Three air transport pilots agreed. A few days later, four Idaho Falls kids panicked the town with a "flying saucer" made from used parts of an old phonograph, burned-out radio tubes and various discarded electrical parts.

This is not to say that Lewiston's skies have not seen some legitimately amazing sights. On December 24, 1930, a meteor exploded over north Idaho at 9:57 p.m. Light from the object was reported to have been "a brilliance that was almost like daylight." Most thought that the ensuing "earthquake" that shook buildings all over north Idaho was from the object crashing, but it was more likely an effect of the concussion wave from the explosion. A large meteor lit up Lewiston's night on March 28, 1987. An air traffic controller in Spokane described it as having "a bright tail, a green glowing head. It appeared very close, fairly large."

BEWARE OF "GYPSIES"

A very pregnant Katherine Gray and her boyfriend, Joseph Dwyer, were operating off a shoestring budget in 1980 as they hitchhiked their way across the country. After Katherine gave birth to their daughter, Jolene, in a Las Vegas hospital, the couple headed for Idaho, where Dwyer was

planning to pan for gold. By the time they reached Lewiston with Jolene in a backpack, the young family was in dire circumstances. On July 7, a band of "gypsies"—a group of travelers in fancy white trailers—loaned the couple sixty dollars at the old KOA campground and took the baby after having paperwork notarized.

Far from joining a gypsy band, the baby was actually in the care of Mrs. Dorothy Groffo and her husband, who were caravanning around the country with friends and returning home on the East Coast. Jolene's grandfather, Bernard Gray, sought to find the child and stop the "adoption." He finally located four-month-old Jolene in August in Middleton, Massachusetts, not far from where he lived. Mother and child were reunited. No criminal charges were filed, but custody was awarded to Mr. Gray.

AN ALL-AMERICAN RINGER

David McFarland, a Nez Perce, was one of the greatest football players in the United States as a halfback on the Carlisle Indian Industrial School team, in Carlisle, Pennsylvania, from 1894 to 1897, a decade before Jim Thorpe rose to fame at the school. Standing five feet, seven inches, McFarland weighed 160 pounds and was noted by the team physician for his exceptional chest expansion. The Carlisle team proved more than a match for some of America's best universities.

In August 1897, newspapers erroneously reported that McFarland had been kidnapped by members of the Nez Perce tribe to keep him from returning to school at Carlisle. McFarland remained strongly connected with the school throughout his life, writing in one letter to the school superintendent that he wished "to be remembered by my friends, all that know me at Carlisle, as one of the old member of the foot player [sic]."

In 1975, Washington State University and the University of Idaho agreed to drop the 1898 game from their records. Why? The Idaho team had tried to insert McFarland into the game. Supposedly, boosters went from Moscow to Lapwai to pick him up. He was enrolled as an agriculture student by the time McFarland arrived. Washington State cried foul and refused to play after he repeatedly punted the ball more than seventy yards warming up for the game.

McFarland would later coach at Idaho for two years. Legendary coach Pop Warner unsuccessfully tried to recruit McFarland as his assistant when

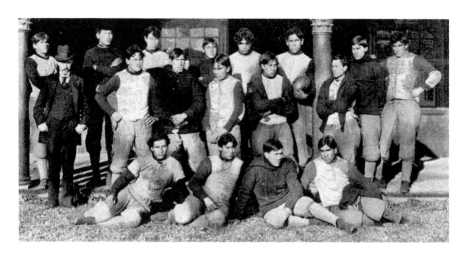

Carlisle's 1897 football team (William Bull, coach). McFarland is standing in the center of the middle row. Reprinted from *Harper's Weekly*, October 30, 1897.

Warner arrived at Carlisle in 1899. In the fall of 1905, he was an assistant football coach at Lewiston High School. McFarland served for many years as an interpreter for the tribe and died in Lewiston of acute appendicitis in March 1929.

CLOUDS WITH A DIFFERENT LINING

In one of the strangest events ever to occur in Lewiston, the town found itself covered in small, horned toads on September 1, 1907. One of Lewiston's characteristic thunderstorms had just blown through the valley. The storm inundated the city with a quarter inch of rain in its first five minutes. After the downpour subsided, the walks were covered by the tiny amphibians. The entire business section of town was covered, as was the residential area on Normal Hill. The sidewalks were so blanketed by the toads that people found it impossible to walk without squashing the animals underfoot. Many people just stayed indoors rather than attempt to navigate through the mess.

Business owners tried to sweep the toads from the sidewalks. They just hopped back as fast as they were tossed into the dirt streets. A local observer noted that the toads must have enjoyed the smooth, wet surface of the concrete sidewalks, which were an innovation at the time.

Lewiston had no paved streets until 1909. In 1953, the town of Leicester, Massachusetts, was deluged by a fall of toads. Children were able to gather them up by the bucketful.

EYEWITNESS TO INFAMY

Hallett Abend came to Lewiston in the mid-1890s with his widowed mother to live near her relatives. He attended Lewiston High School and worked as a cub reporter for the *Lewiston Tribune*. His poetry appeared in the *Tribune* and various literary journals. After graduating from Stanford University, he joined the *Spokesman-Review* (Spokane, Washington) in 1909. A stint in Hollywood writing scripts for silent films was followed by work at the *Honolulu (Hawaii) Star-Bulletin*, the *Idaho Daily Statesman* (Boise) and the *Los Angeles Times*.

Hallett Abend, 1896.

In 1926, he was offered a job as chief *New York Times* correspondent in Peking (Beijing), China, as part of a six-month vacation but ended up staying fifteen years and reported on the invasion of China by Japan. In 1929, he became an "international incident" when the Chinese government took exception to the articles he wrote that advised the American government not to invest in the Asian market. The Chinese government ordered him to be deported, but the order was later rescinded. He wrote the books *Tortured China* and *Can China Survive?*

By 1937, he was bureau chief for the *New York Times* in Shanghai and, on August 22, was among those wounded

when a heavy artillery shell exploded in the heart of the international quarter. He was beaten by Japanese military police. His reporting of the "Rape of Nanking" in 1937 exposed the extent of Japanese atrocities in the city. Humorist and political commentator Will Rogers regarded Hallett as perhaps the best-informed American on Chinese affairs. He died in 1955.

LINES ON THE ROAD JUST LIKE DOTS

"Son, you're going to drive me to drinkin' if you don't stop drivin' that hot rod Lincoln." Many people are familiar with the rock-and-roll song "Hot Rod Lincoln," whose 1972 cover by Commander Cody and His Lost Planet Airman reached number nine on the *Billboard* charts in the United States. So what, you ask?

Although the lyrics refer to San Pedro, California, the "Grapevine Hill" in the song was actually the old Lewiston Spiral Highway.

Driving a hopped-up '48 Lincoln, the song's writer, Charlie Ryan, had raced a friend driving a Cadillac up the grade when they were returning to Spokane from a play date at the old Pair-a-Dice Club in north Lewiston in 1950. In 1960, Charlie and his group, the Timberline Riders, peaked at number thirty-three on the *Billboard* charts with his rendition of his rockabilly classic. Ryan died in 2008.

A PIONEER OF THE ATOMIC AGE

Rex Pontius graduated from Lewiston High School in 1927 and went to work for the Forest Service to pay for his education at the University of Idaho, where he graduated Phi Beta Kappa in 1932. Appointed a Rhodes Scholar in 1933, he received a degree at Jesus College, Oxford, in 1935 and rowed for Oxford. A graduate fellowship allowed him to do advanced research in low temperature physics at Clarendon Laboratory. He received his PhD in 1937. He met his future wife on one of his voyages home across the Atlantic aboard the *Queen Mary*.

The summer of 1942 found him as a chief researcher for the Manhattan Project, working to create a manageable production method for Uranium 235. He worked for four years on atomic energy projects. His research in

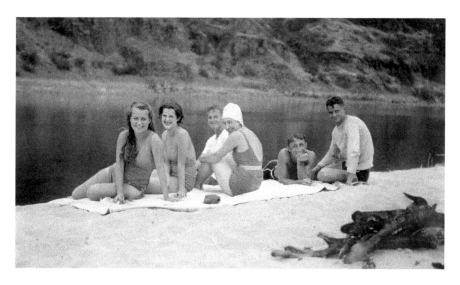

Rex Pontius (far right) with friends, 1934. *Courtesy of Susan Sauve.*

gas diffusion technology would earn him two international patents. After briefly teaching at Columbia, he moved to Rochester, New York, to work for Eastman Kodak, where he pursued research in color photography. He died in January 1987.

LOVERS' LANE WITH A DISTINCT ODOR

Be careful when parking your car for a late night kiss. Three armed men raided cars with steamed windows all over town on November 6, 1931, stripping fourteen men and women of their jewelry and locking them in the Dill Slaughterhouse two miles south of the city. Two of the robbers pulled alongside cars and ordered the occupants out, seized their valuables and took the victims to the "holding pen" at the slaughterhouse. The third gunman acted as guard.

All of the action took place between 9:00 p.m. and midnight, leaving the victims in the cold, locked building overnight, complete with all the smells that come with an abattoir. Two of the "inmates," Lester Getz and Ira Von Bargen, broke the lock in the morning and walked back to town to file reports with the police. No one had a clue who the robbers were. Getz

and Von Bargen refused to divulge the names of their female companions. Chivalry was not dead.

Simultaneous TKO with a Deadly Twist

You know the comedy routine where the boxers simultaneously knock each other out? Well, the scenario wasn't so funny on April 24, 1885. Stock ranchers Peter Prasil and James Flynn got into a heated disagreement over something. Their bodies were found near each other with pistols and clubs by their sides just outside of town. Local officials speculated that they had gotten into a fight and had killed each other in what people used to call a Kilkenny after an old story in which two cats fought to the death and ate each other up, leaving only their tails.

And Finally, a Premonition

On June 18, 1869, an old Kalispel Indian named Quilquilzom ("White Bones") had a dream. While fishing one day at the foot of Flathead Lake in Montana, some twenty-eight miles from the St. Ignatius Mission, he all of a sudden saw something that seemed, as he said, to take his breath away. "I saw Sinze Chitas," which was the Kalispel name ("Brother Left-handed") for Brother Vincent Magri, who had the year before transferred to work in the Idaho Territory with Father Joseph M. Cataldo.

"I saw him," continued the old man, raising his eyes and pointing with his hand to the sky, "riding in a most beautiful thing." The only description that he could give of the "thing" was that it resembled a chariot and was very beautiful. The priest later learned that Father Magri had died that day in Lewiston.

ABOUT THE AUTHOR

S ince the 1980s, Steven Branting has been
honored for his depth and variety of research
and fieldwork by many of the nation's premiere
science, geography, history and preservation
organizations, including NASA, the American
Association for State and Local History, ESRI
and the Society for American Archaeology. From
2001 to 2010, he was the lead investigator for the
5th Street Cemetery Necrogeographical Study, an
internationally acclaimed project that modeled
the best practices in historical field work and
discovered scores of burials still remaining in
Pioneer Park, the site of Lewiston's first and later
abandoned graveyards.

Photographer: Barry Kough,
Lewiston *Tribune*.

In 2011, the Idaho State Historical Society conferred on him the Esto
Perpetua Award, its highest honor, citing his leadership in "some of the most
significant preservation and interpretation projects undertaken in Idaho,"
whose governor awarded him that year's Outstanding Cultural Tourism
Award for showcasing Idaho's heritage.

In 2013, The History Press published *Historic Firsts of Lewiston, Idaho:
Unintended Greatness*, his signature study of events that have set Lewiston
apart in Idaho, the Pacific Northwest and the nation since the city's
founding in 1861.

Also in 2013, the National Society of the Daughters of the American Revolution awarded him its coveted Historical Preservation Medal, the first to an Idahoan.